IMAGES
of America
STONE HARBOR
REVISITED

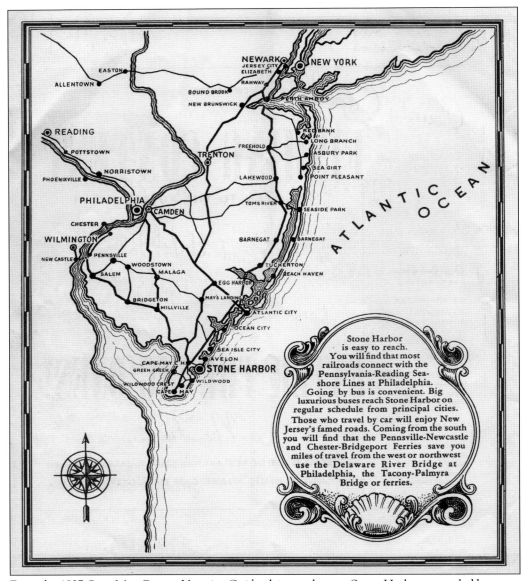

Stone Harbor
is easy to reach.
You will find that most
railroads connect with the
Pennsylvania-Reading Sea-
shore Lines at Philadelphia.
Going by bus is convenient. Big
luxurious buses reach Stone Harbor on
regular schedule from principal cities.
Those who travel by car will enjoy New
Jersey's famed roads. Coming from the south
you will find that the Pennsville-Newcastle
and Chester-Bridgeport Ferries save you
miles of travel from the west or northwest
use the Delaware River Bridge at
Philadelphia, the Tacony-Palmyra
Bridge or ferries.

From the 1927 *Cape May County Vacation Guide*, this map locates Stone Harbor as nestled between the resort communities of Avalon (seen here misspelled as "Avelon") and Wildwood, and reachable by car, bus, or train. (Barbara Colombo, owner of Coastal Postal in Ocean City, New Jersey.)

ON THE COVER: The "collegiate" swimsuits were all the rage in the early 1920s. The Jantzen Company developed a stretchy, ribbed jersey fabric that was more comfortable than the heavy wool used for the swim costumes of the Victorian and Edwardian eras. Photographs of human pyramids were typical of the times and were a good way to squeeze a large number of people into one photograph. (Authors' collection.)

IMAGES
of America

STONE HARBOR
REVISITED

Donna Van Horn and
Karen Jennings

ARCADIA
PUBLISHING

Published by Arcadia Publishing
Charleston, South Carolina

Printed in the United States of America

Library of Congress Control Number: 2015942542

For all general information, please contact Arcadia Publishing:
Telephone 843-853-2070
Fax 843-853-0044
E-mail sales@arcadiapublishing.com
For customer service and orders:
Toll-Free 1-888-313-2665

Visit us on the Internet at www.arcadiapublishing.com

*This book is dedicated to our parents, Jane and Carey Boss,
who spent their lives living the dream that is Stone Harbor.*

CONTENTS

ACKNOWLEDGMENTS

Aaron Leaming Sr., the first European owner of Seven Mile Beach, was our eighth great-grandfather. Growing up in a family who cherished their deep ancestral roots, we learned a respect for the pioneering spirit that first brought our family to Cape May County long before the American Revolution. Identified as whaler yeomen, the Leamings, like many other early settlers, turned to farming when the whaling industry failed, and found the barrier islands perfect places to graze their livestock. We spent the summers of our youth in the home of our great-grandfather in Cape May Court House, surrounded by the stories and artifacts of bygone days. China salvaged from ocean wrecks, vintage sailing and fishing gear, property deeds hundreds of years old, and boxes of old pictures filled every available storage space, and our rainy days were spent digging through the ancient attic, looking for more. The four-mile trip to the beach in Stone Harbor was made almost daily in the summer until 1971, when our parents sold the family home and moved to the island. The love affair with Stone Harbor continues for our family, just as for generations of other families, and we celebrate not only its history but also the bright future of the special place known as "the Seashore at Its Best." The history of Stone Harbor has been told many times through pictures and iconic postcards. We seek to add to the storied history of this unique Jersey Shore community, focusing on the family-centric nature of this all-American town. We sought out little-known facts about the island's earliest days and photographic images that have never before been seen outside of the private family collections to which they belong. We must thank the following individuals for sharing their cherished photographs and documents with us, greatly enhancing the story of Stone Harbor that we tell: Barbara Colombo, owner of Coastal Postal in Ocean City, New Jersey (CP); Terrie Cwick and the Stone Harbor Museum for access to its extensive collection (SHM); and Lauren Cook-Kinsman (LCK), Charles Berger (CB), Laura Newman (LN), Thomas Keown (TK), and Robbin Drummond (RD) for photographs from their family collections. Unless otherwise noted, all photographs appear courtesy of the authors' personal collection.

INTRODUCTION

Stone Harbor, located in Cape May County, New Jersey, is the quintessential all-American resort town. A year-round home to a lucky few and a summer vacation destination for thousands, Stone Harbor has a long and storied history that "locals" take great pride in, yet sadly eludes most visitors. Although separated from the mainland by four miles of marsh and back bays, Stone Harbor's past, present, and future cannot be separated from that of the mainland. In fact, there is a direct connection between Stone Harbor and the Pilgrims of Plymouth Colony. Historically, the connecting link between the settlement in the colony of Plymouth and the earliest settlement in Cape May County is the last line from the manuscript known as the "Wast Book" of Col. John Gorham, written during the Louisbourg Expedition in 1745: "Hannah- maryd a Wheedling boath movd to Cape-may." In today's English, direct Pilgrim descendants removed by only two generations Hannah Gorham and Joseph Whilldin got married and relocated to Cape May County around 1695, when Joseph took title to 150 acres in what is now Lower Township. Hannah was the granddaughter of John Howland, who, as a Pilgrim, arrived in Plymouth Colony on the *Mayflower*. John Howland's story is an interesting saga that has been well documented. He traveled on the *Mayflower* as an indentured servant to John Carver, yet came very close to never arriving at his destination. During the voyage, there was a sudden storm in which Howland fell overboard. He managed to grab a top sail halyard that was trailing in the water and was safely hauled back on board by others who had just happened to see him fall. A signer of the Mayflower Compact, Howland eventually married Elizabeth Tilley, and it was their great-granddaughter Hannah Whilldin who married Thomas Leaming of the very prominent yeomen Leaming family, early settlers of Cape May County. According to Rev. Paul Sturtevant Howe, author of *Mayflower Pilgrim Descendants in Cape May County New Jersey: Memorial of the Three Hundredth Anniversary of the Landing of the Pilgrims at Plymouth*, there were more descendants of the *Mayflower* in Cape May County, New Jersey, than in Plymouth, Massachusetts, in 1921. In *Cape May County Story* by George F. Boyer and J. Pearson Cunningham, the Leamings and other early settlers were described as hardworking men who went whale fishing and farmed, while building homes, churches, and roads. Jeffrey M. Dorwart identifies 35 whaler yeomen families in his book *Cape May County, New Jersey: The Making of an American Resort Community*. Names familiar to today's seasonal tourists, such as Corson (Corson's Inlet), Leaming (Leaming's Run Gardens), Osborn (Osborn's Appliances), and Townsend (Townsend's Inlet) join those less familiar yet equally important to the early history of the area. The Cresses, Garretsons, Hands, Ludlams, and Whilldins, just to name a few of these founding families, all played critical roles leading to the settlement and eventual development of Cape May County and, ultimately, Stone Harbor.

Christopher Leaming first came to Cape May County around 1691, when he left his family in Long Island seeking the promise of "good advantages to the adventurer," as noted by his grandson Aaron Jr. Shortly thereafter, his 18-year-old son, Thomas, joined him in Cape May County, where Leaming worked as both a whaler and a cooper. In 1703, Thomas "went to Cohansie, and fetched

a brother, Aaron." It was this Aaron Leaming Sr. who, in 1722, purchased the narrow stretch of barrier island paralleling the mainland that became known as Leaming's Beach, originally used by Leaming as grazing pasture for cattle, horses, and sheep. Shares of the beach were eventually rented for whaling, timbering, and oystering. Aaron Leaming Jr. even established a successful saltworks on the island. Substantially undeveloped, the island remained in the Leaming family for 132 years, when it was eventually sold to the Tatham family, who constructed a farmhouse and barn in the 1850s. By 1885, what was now known as Seven Mile Beach remained the only undeveloped barrier island in the county. According to Jeffrey M. Dorwart, "The salt marshes were wider and the channels and thoroughfares more treacherous between this beach and the mainland than for any other barrier island, discouraging travel and delaying development." When, in 1891, a permanent railroad link was finally established to the rapidly growing resort community of Sea Isle City, just to the north across Townsend's Inlet, Joseph L. Wells and a group of Pennsylvania investors purchased 3,000 acres from the Tathams. Under Well's leadership, the north end of Seven Mile Beach was incorporated as Avalon in 1892. It was not until the South Jersey Realty Company purchased the three-and-a-half-mile southernmost portion of the island in 1907 that what would eventually become Stone Harbor really began to take shape. Historians speculate that the name "Stone Harbor" came from a 19th-century English sea captain named Stone, who rode out a dangerous Atlantic storm by sailing into the protected back bays behind the barrier island. This theory is very likely, as references to sailing races held in Stone Harbor back bays and sponsored by the Stone Harbor Yacht Club appear in the *Cape May Spray*, the county's weekly newspaper, as early as 1895.

It was with this $90,000 purchase that the names of brothers Howard, Reese, and David Risley became forever linked to what is now known as Stone Harbor. Following the example of the successful development of neighboring Sea Isle City to the north and Wildwood to the south, the Risley brothers established real estate development corporations and sold shares, creating great excitement and a boom in development that included the construction of cottages, hotels, shops, and restaurants. With the linking of Stone Harbor directly to the mainland in Cape May Court House via a roadway and bridge in 1911, the Stone Harbor Ocean Parkway guaranteed continued growth of the community. Now known as Stone Harbor Boulevard, this thoroughfare led directly to what was to become the center of Stone Harbor's universe—Ninety-Sixth Street. The original beachfront boardwalk was destroyed during a storm in 1944, leaving the center of town as the hub of commercial activity. Much like any other main street, the four-block stretch of road that bisects the island from the back bay to the beach now hosts shops, restaurants, bars, and entertainment for all ages. On any given night during the summer tourist season, hundreds of families stroll the street, window-shopping, playing miniature golf, going to a movie, and eating ice cream. Establishments such as Springer's Ice Cream and Fred's Tavern have seen generations of locals and tourists alike wait in line, uncomplaining, to spend part of their vacation inside. It is all part of the tradition that is Stone Harbor: the Seashore at Its Best!

One

DEVELOPING A DREAM

From the early days of the original inhabitants, the Lenni-Lenapes, Cape May County and its barrier islands have been the place for dreamers. English court physician Dr. Daniel Coxe bought 95,000 acres of the Cape May peninsula from the Lenape around 1687 and involved the earliest settlers in whaling. English colonists from Connecticut and New York came to the area to work as coopers, cordwainers, carpenters, or blacksmiths to support the whaling industry.

These first settlers embodied the English concept of a yeomen as owners of small landed estates who cultivated the land and held a high level of respect in the community. Many settlers turned to lumbering and farming when the whaling industry faltered. Their tenacity is evidenced in their ability to survive great hardship, such as the influenza-like plague of 1714, which killed almost 10 percent of the county population.

When Aaron Leaming Sr. purchased Seven Mile Beach in 1722, he dreamed of island grazing pastures for his livestock, safe from natural predators and poaching. His son Aaron Jr. dreamed of financial success when he established a salt-processing plant on the island. But it took the vision of the South Jersey Realty Estate Company in 1907 and the Risley brothers to develop the community of Stone Harbor into the dream it is today.

Clearing the island of scrub pine and sand dunes, the brothers built sprawling mansions and small cottages, paved roads and created sidewalks, dredged basins and established a water supply, and most importantly, opened the Stone Harbor Parkway, forever connecting the island to the mainland in Cape May Court House. Their creative marketing and advertising offered free building lots to investors who came from Philadelphia and New York to be part of the newest Jersey Shore resort community.

In 1930, Julius Way described Stone Harbor as the "Wonder City," at which "no other resort in the world is there better ocean bathing . . . where every known water sport can be safely enjoyed. It is the ideal vacation playground for all the family." Clearly, the Risley brothers' dream had quickly been realized.

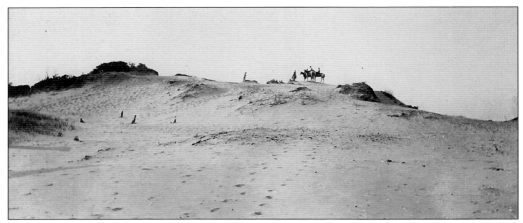

Above, an early photograph shows riders on horseback exploring the dunes that once dominated Seven Mile Island. In 1897, Lewis Townsend Stevens described the barrier islands as woods of grand timber, including "pine, red, white and black oak, sassafras, red and white cedar, holly, magnolia, wild cherry, persimmon, sweet gum, beech, plum and other varieties." The twisting channels and wide marshes isolated the island from the mainland, and two deepwater inlets cut it off from Sea Isle to the north and Wildwood to the south. This early map of Cape May County shows Stone Harbor at the southernmost end of Sea Island on Seven Mile Beach. The Leaming family maintained ownership of the island until 1854, when it was sold to Joseph S. Silver, then to the Tatham family in 1855, and again to Joseph S. Wells and Frank H. Siddall in 1887.

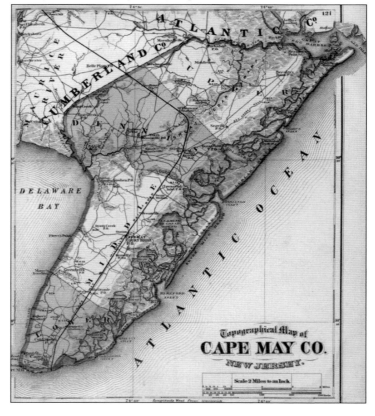

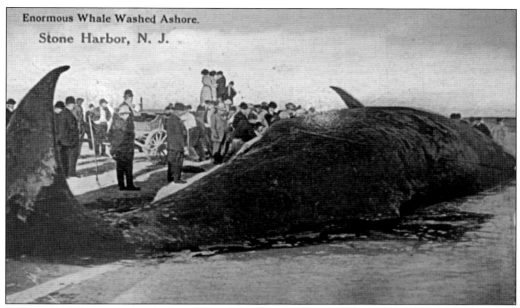

Enormous Whale Washed Ashore.

Stone Harbor, N. J.

In describing the whaling industry of Cape May County, George F. Boyer details the end of a whale hunt as follows: "Waiting for high tide, they towed it ashore to the safe harbor of Town Bank, or at times to the various island ocean beaches, then called Five Mile and Seven Mile Beach." The last record of whaling in the area was documented when Aaron Leaming leased Seven Mile Beach to whalemen for 30 days in 1775. Thus, it is not surprising to see this early postcard with a whale washed ashore. In 1974, longtime resident Walter Hendee discovered the ribs of a wreck about a half mile south of 121st Street. While there is disagreement over the actual age of the wreck, it is just one of numerous ships that surely lie as yet undiscovered in the sand near Stone Harbor. (Below, SHM.)

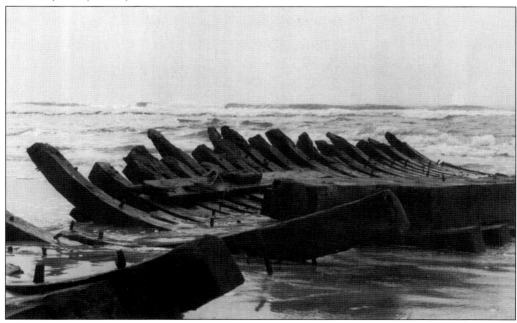

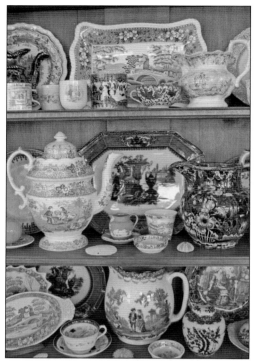

Merchant ships carried cargoes of simple everyday items like china, which often washed ashore following a wreck. Ed Michaud, a diver and treasure hunter, states that every stretch of coastline has its "china wreck," with at least three of them off the Cape May County coast. In 1970, divers salvaged about 200 pieces of china. Much of the English transferware china seen at left was salvaged by the Sayre and Dougless families off the beaches of Stone Harbor, Avalon, and Sea Isle City following wrecks. The *Prospectus* photograph below is captioned, "Uncle Sam's Boys who patrol the beaches. Crew and families of the Life-Saving Station on the Miramar property." The US Life-Saving Service purchased property for the first station near the Tathams' farm in 1855. Built in 1872, then relocated in 1893, Tatham's Station No. 35 was protecting the coast long before the Risleys arrived. (Below, CP.)

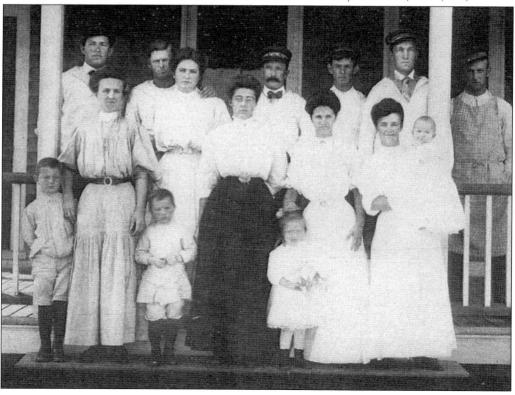

In 1907, the South Jersey Realty Company purchased the three-and-a-half-mile southern end of Seven Mile Beach. The company's officers—president Howard Risley, vice president Reese Risley, and secretary-treasurer David Risley—used forward-thinking marketing strategies to entice investors to purchase bonds in exchange for free lots. Postcards and newspaper advertising flooded Philadelphia and surrounding areas, offering free excursions to potential investors via the Pennsylvania Railroad. (CP.)

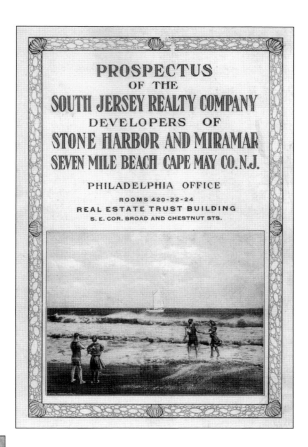

PROSPECTUS
OF THE
SOUTH JERSEY REALTY COMPANY
DEVELOPERS OF
STONE HARBOR AND MIRAMAR
SEVEN MILE BEACH CAPE MAY CO. N.J.

PHILADELPHIA OFFICE

ROOMS 420-22-24
REAL ESTATE TRUST BUILDING
S. E. COR. BROAD AND CHESTNUT STS.

This advertisement from the 1912 *Cape May Court House Cook Book* touts free inspection trips to Stone Harbor. The Risleys leveled the soaring sand dunes to make way for streets and provided housing for their work crews, who built not only homes, hotels, and places of business but also the infrastructure to support them.

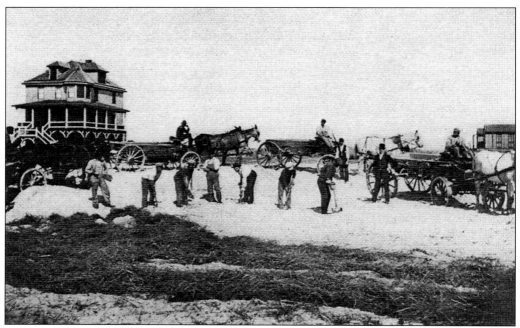

Work crews grade the ground for what would become the Harbor Inn. The new residence of William Schuck is seen in the background. This *Prospectus* photograph is captioned, "Bath-houses and pavilion . . . note how the sand hills are forming in front of the pavilion. When it was built a few years ago, the tides rose under it, but like so many beaches on the South Jersey Coast, the ocean has since receded, adding to the width of the beach front." The first stationary bathhouses were narrow wooden changing cabins set in rows parallel to the beach just beyond the high-tide line. They provided a place for bathers to change out of their street clothes, as strict etiquette forbade wearing bathing clothes for anything other than bathing. (Both, CP.)

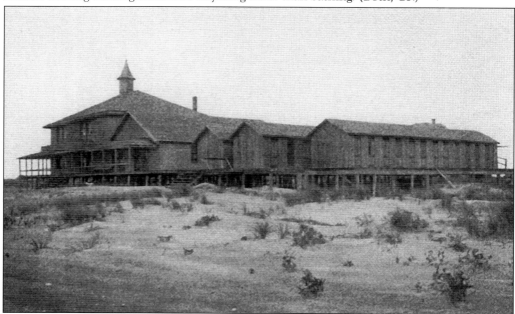

Dated 1909, this bond guarantees the purchaser the return of his $500 investment in 20 years, along with a free building lot. The money raised funded the construction of the fledgling community's infrastructure: roads, sewers, water, and electric lines. The photograph below captures a group of investors who were instrumental in building the oceanfront fishing pier and organizing the Stone Harbor Fishing Club at Eighty-Sixth Street. In the second row, second from right, is John Kienzle. (Right, CP; below, RD.)

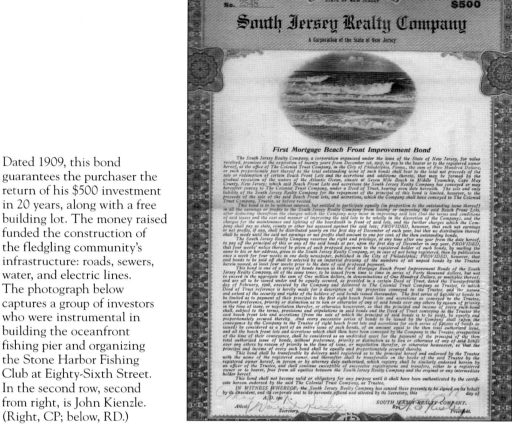

15

Pictured here are the front and back of the inventive postcard advertisements distributed by the South Jersey Realty Company. The Risley brothers knew that no matter how enticing their planned development by the sea was, people had to have easy access to the island. The resort communities of Sea Isle City to the north and Wildwood to the south were already thriving. However, the salt marshes and channels that separated Stone Harbor from Cape May Court House on the mainland were wider and the waters more treacherous than those of their neighbors. The developers of Stone Harbor promised investors transportation to the mainland via the Stone Harbor Turnpike, Trolley, and Canal System, combined with a connection to the Pennsylvania Railroad. Although they purchased land on the mainland as part of this plan, the plan never fully came to fruition.

Post Card

PLACE A ONE-CENT STAMP HERE

THIS SPACE FOR CORRESPONDENCE

South Jersey Realty Company
 Gentlemen:
 Without incurring any obligation, I should like to receive details of your **Ocean Parkway Construction Bonds** with **Free Allotment of Lots.**

Name _____

Street_____

City_____

State _____

THIS SPACE FOR ADDRESS ONLY

South Jersey Realty Company

915 Real Estate Trust Building

Broad and Chestnut Sts.

PHILADELPHIA, PA.

Katherine Kienzle models the latest in beach attire in this photograph taken around 1915 on the beach in front of her Stone Harbor home. Her Edwardian bathing costume enhances her stylish tiny waist.

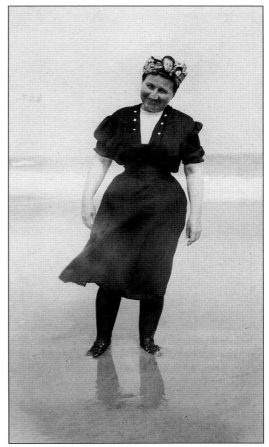

Just as today, early visitors to Stone Harbor availed themselves of the shopping and recreational options available in nearby Cape May Court House. Guests at the Stone Harbor Country Club could enjoy a morning of golf, then return to the island for an afternoon at the beach.

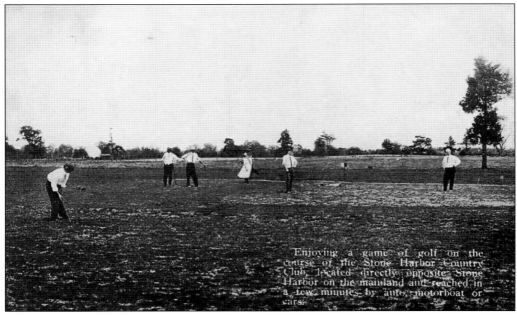

Enjoying a game of golf on the course of the Stone Harbor Country Club, located directly opposite Stone Harbor on the mainland and reached in a few minutes by auto, motorboat or cars.

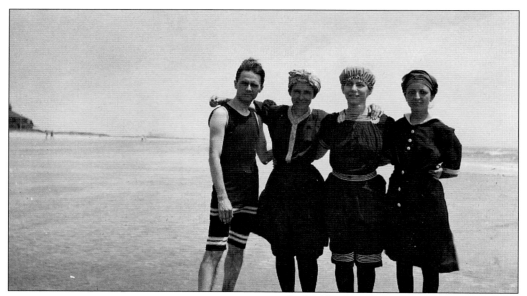

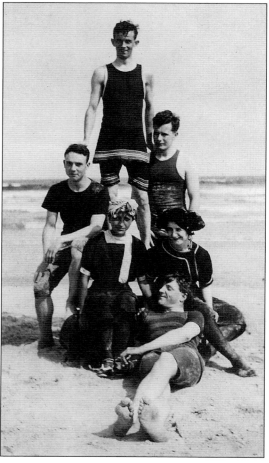

Ladies' bathing costumes of the early 1900s were designed more for modesty than for swimming. Skirts were flouncy, specifically to hide the buttocks and groin, and corsets, blouses, and jackets were worn to conceal the breasts. Waterproof oilcloth bonnets protected one's hair, and the weight of nearly 22 pounds of wet wool fabric kept most bathers confined to the shallow waters. The 1920s brought the unisex bathing suit, designed by Jantzen Knitting Mills specifically for swimming. The goal was to make a bathing costume that was aquadynamic, modest, and attractive. (Both, RD.)

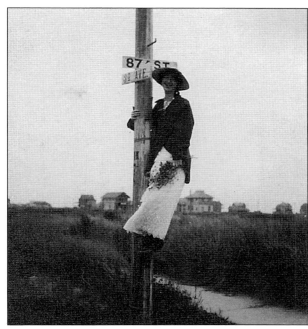

Even a day of gathering flowers along the beach or fishing called for a certain level of appropriate attire. Mary Kienzle, climbing the street sign at Eighty-Seventh Street and Third Avenue, and an unknown sailor both wear lacy skirts, tailored jackets, and straw boater hats to protect their complexions from the summer sun. Bathing costumes were reserved only for swimming and were never worn anywhere other than the beach. (Right, RD.)

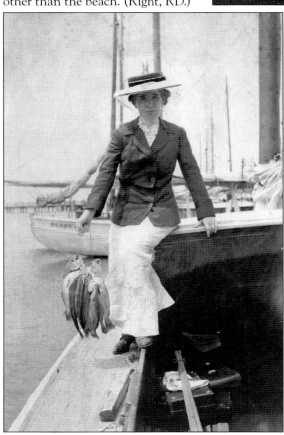

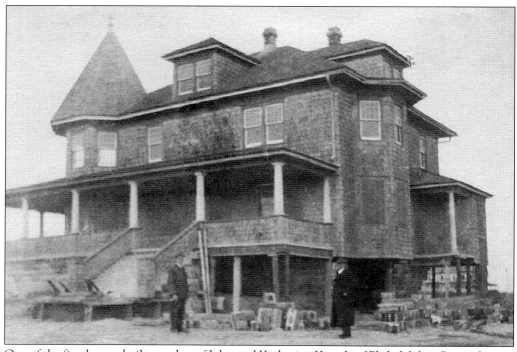

One of the first homes built was that of John and Katherine Kienzle of Philadelphia, Pennsylvania. Completed in 1914 and known as Cottage Mignon, this expansive beachfront home at Eighty-Eighth Street and First Avenue was the first in Stone Harbor to have a bulkhead around it to protect it from the ocean waves. In his 1930 obituary, John Kienzle is recognized as "one of the pioneers in Stone Harbor's development" and is credited with the establishment of the fishing pier, the Stone Harbor Yacht Club, and St. Paul's Catholic Church. He was the director of the Stone Harbor Terminal Railroad and the First National Bank of Stone Harbor. (RD.)

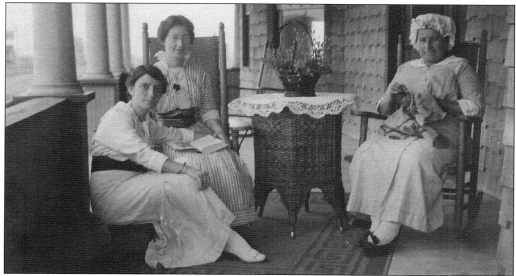

The expansive front porch of Cottage Mignon offers the perfect place to enjoy a summer afternoon for, from left to right, Charlotte, Mary, and Katherine Kienzle.

John Kienzle's obituary notes that "during his latter years he greatly enjoyed his summers in his boat, pursuing his favorite pastime in the waters surrounding this resort." He was president of the Stone Harbor Terminal Land Company, which owned considerable acreage along the boulevard.

This group of young men was photographed while picnicking in Stone Harbor in 1920. Not unlike the college students of today who relocate to the resort seeking summer employment mixed with fun in the sun, these young men certainly look to be enjoying themselves.

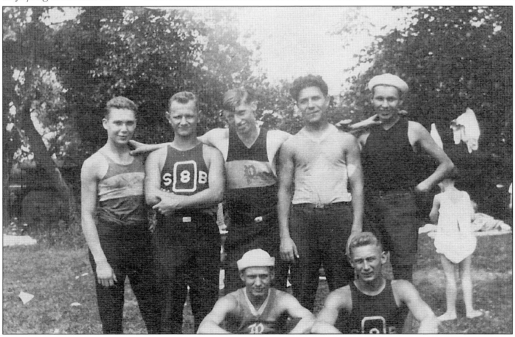

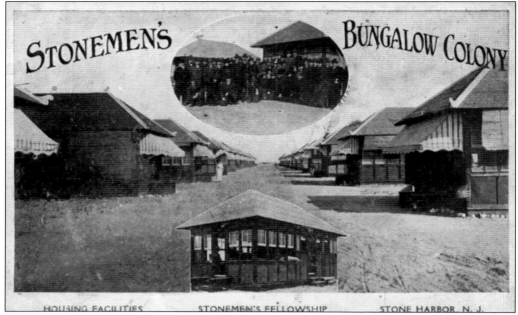

The Risleys kept the needs of those with more modest means in mind and constructed three streets of small 12-by-24-foot bungalows designed to maximize limited space, much like a cabin found on a yacht. In 1917, a few streets of the properties were bought by a religious group known as the Stoneman's Fellowship. The fully furnished bungalows were rented to its members in an early type of vacation club.

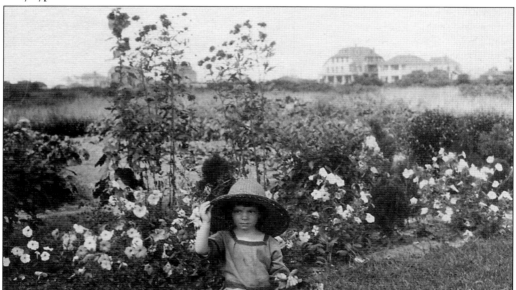

Catherine Fasy is pictured here in the garden at her grandparents' second home on Eighty-Eighth Street around 1928. The Kienzle family was known for their carefully tended gardens and beautiful flowers. Still relatively undeveloped, Stone Harbor was covered with native plants, including bayberry, prickly pear, elderberry, beach plum, and spirea. Add hydrangea, hollyhocks, and rose of Sharon, and the result is a yard to be proud of. (RD.)

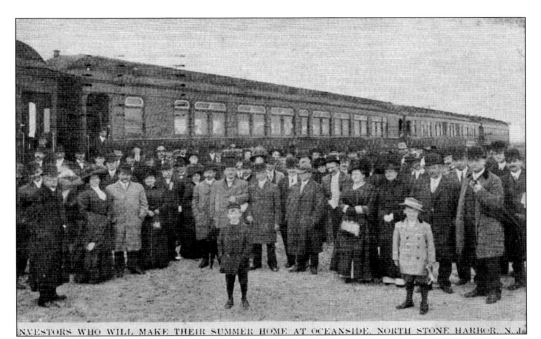

INVESTORS WHO WILL MAKE THEIR SUMMER HOME AT OCEANSIDE, NORTH STONE HARBOR, N.J.

In 1889, the West Jersey Railroad Company was granted the right to build a line that would run the entire length of Seven Mile Beach. Prior to 1889, when the first train went into operation, the only access to the island was by boat. Droves of potential investors often arrived by train, as can be seen in this early postcard.

This page from the 1926 *County Resort Guide* touts Stone Harbor as a "Different Summer Paradise" and the "Best Family Resort." The beaches of the South Jersey Shore are described in *The Beach: The History of Paradise on Earth* as sloping "so gently that one can wade out shoulder-deep and bathe in perfect safety, with no seaweed to tangle the feet, or shells or stones to bruise them." What made Stone Harbor "different" and "paradise" was the perceived exclusivity that was created by early advertising such as this. (CP.)

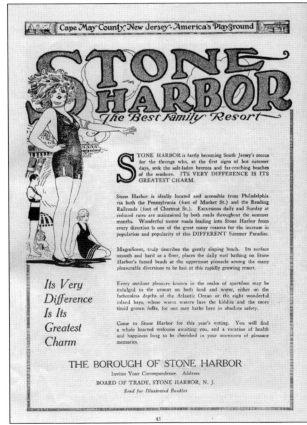

Cape May County: New Jersey - America's Playground

STONE HARBOR
The Best Family Resort

STONE HARBOR is fastly becoming South Jersey's mecca for the throngs who, at the first signs of hot summer days, seek the salt-laden breezes and far-reaching beaches of the seashore. ITS VERY DIFFERENCE IS ITS GREATEST CHARM.

Stone Harbor is ideally located and accessible from Philadelphia via both the Pennsylvania (foot of Market St.) and the Reading Railroads (foot of Chestnut St.). Excursions daily and Sunday at reduced rates are maintained by both roads throughout the summer months. Wonderful motor roads leading into Stone Harbor from every direction is one of the great many reasons for the increase in population and popularity of this DIFFERENT Summer Paradise.

Magnificent, truly describes the gently sloping beach. Its surface smooth and hard as a floor, places the daily surf bathing on Stone Harbor's famed beach at the uppermost pinnacle among the many pleasurable diversions to be had at this rapidly growing resort.

Every outdoor pleasure known in the realm of sportdom may be indulged to the utmost on both land and water, either on the fathomless depths of the Atlantic Ocean or the eight wonderful inland bays, whose warm waters lure the kiddies and the more timid grown folks, for one may bathe here in absolute safety.

Come to Stone Harbor for this year's outing. You will find a whole hearted welcome awaiting you, and a vacation of health and happiness long to be cherished in your storeroom of pleasant memories.

Its Very Difference Is Its Greatest Charm

THE BOROUGH OF STONE HARBOR
Invites Your Correspondence. Address
BOARD OF TRADE, STONE HARBOR, N.J.
Send for Illustrated Booklet

45

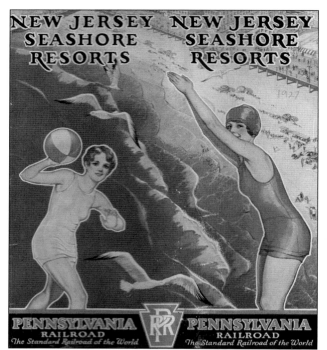

The close connection between the Pennsylvania Railroad and the communities along the southern New Jersey barrier islands is evident in this 1927 travel brochure. The *Last Train to Paradise: Henry Flagler and the Spectacular Rise and Fall of the Railroad That Crossed an Ocean* includes an anonymous quote that could just as easily apply to the railroad's impact on Stone Harbor as on Key West, Florida: "And now their strange inhabitants, their white and shimmering silences broken only by the cries of gulls and the long roll of blue waves breaking on coral rock are to know the shriek of the locomotive and the roar of the passing trains. The whistle of the locomotive will be heard in the land and another corner of the earth will be put on the civilized map." (Both, CP.)

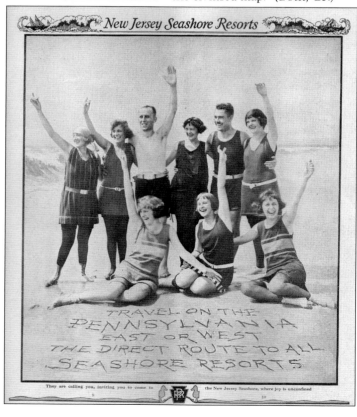

With limited shopping, island residents depended upon mainland farms for their fresh summer produce, such as corn, pole lima beans, tomatoes, and melons. At right, an early photograph from around 1872 shows George Sayre Sr. and his namesake bringing in the hay on their farm in Seaville. Below, posing in front of the family farm in 1915 are, from left to right, George Sayre Jr.; his daughter, Minnie; and his wife, Carrie Holmes Sayre. According to his 1940 obituary, George Jr. "huckstered vegetables in Stone Harbor during the summer season." Part of the summer experience was selecting fresh produce from the back of the huckster's truck for the evening meal. The Sayre property is now recognizable as Teaberry Not Just Antiques and the Abbie Holmes Estate on Route 9.

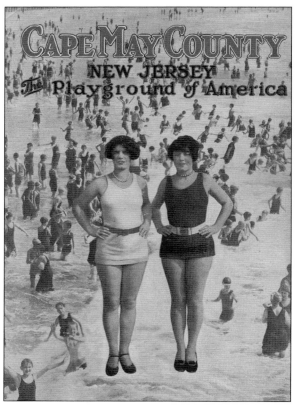

These happy bathers appear in the 1927 *New Jersey Resort Guide*. The female bathing costume of the early 1900s included stockings, bloomers, blouses, gloves, hats, and slippers, leaving little opportunity for physical movement. It took Annette Kellerman, a world-renowned swimming champion from Australia, to redesign the bathing costume into a tight-fitting, one-piece wool garment in 1907. *The Beach: The History of Paradise on Earth* notes that "the last summer before World War I was memorialized in the American press by a spate of stories documenting skirmishes on the beach between proponents of diminished swimwear, and die-hard traditionalists who insisted on the Victorian skirt-and-trouser models." The view in this aerial photograph looks west from the beach to the bay. Few remaining undeveloped building lots are visible, along with the iconic water tower at the corner of Ninety-Sixth Street and Second Avenue that appears in the upper right. (Left, CP; below, CB.)

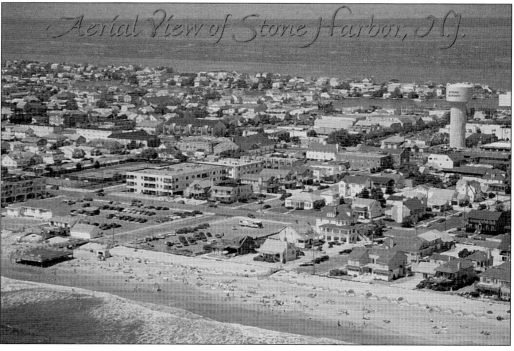

Two

THE THREE BS

Summer at the shore is synonymous with "the three Bs": the beach, the boardwalk, and bathing. In the 1700s, Seven Mile Beach was used for grazing livestock and to process salt. Shipwrecks occasionally left the beach littered with china and household goods, and pirates reportedly roamed the area. Now, the beaches of Stone Harbor are known for their gently sloping sands, pristine waters, and highly trained lifeguards, all of which ensure a safe and pleasant day at the shore.

Ocean bathing has changed dramatically from the time of ancient Greek and Roman myths, when the waters were believed to be stalked by monsters and demons, preying on unwary swimmers. While the Victorians and Edwardians embraced the concept of ocean bathing, their activity was limited by the cumbersome wool bathing costumes of the period. The streamlined bathing suits of the 1920s gave new freedom to swimmers, and today's visitors to the beaches of Stone Harbor embrace surfing, bodysurfing, and ocean swimming with great enthusiasm.

Interrupted only by occasional jetties placed to stem sand erosion, Stone Harbor's public beach extends from Eightieth Street south to 120th Street. For the next few blocks, sailors launch Hobie Cats from a designated docking beach. From there, an environmentally fragile nesting area for endangered birds, including oystercatchers, piping plovers, and least terns, extends south toward Stone Harbor Point and Hereford Inlet. This balance between public use and protected wildlife habitats ensures that Stone Harbor's beach is available to all and utilized in an environmentally friendly manner.

Like other nearby shore points, Stone Harbor's early boardwalk was a popular place for visitors, whether seated above to catch the cooling salt air breezes or lounging below out of the blazing summer sun. With few businesses on it, the boardwalk was reserved primarily for strolling. When it was destroyed by the Great Atlantic Hurricane of 1944, the borough decided not to rebuild. Today, the commercial nature of most boardwalks actually leads many contemporary visitors to specifically choose Stone Harbor due to its lack thereof, which contributes to the quieter family focus of the community.

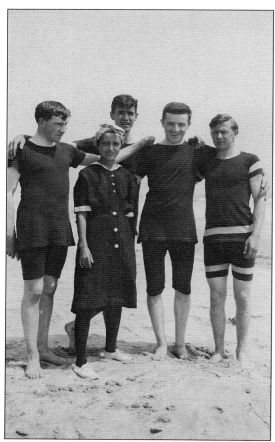

The 1907 *Prospectus* includes the following advertisement: "No finer bathing ground to be found anywhere than on our property, hard, level and free from mud bars, far enough from Philadelphia and New York to be uncontaminated by rubbish or sewage and washed by waters much warmer than those of the more northerly resorts . . . where cold, damp winds and Labrador currents make a prolonged bath dangerous and debilitating. Ropes are unnecessary and are never used for bathing, even by ladies and children on Seven Mile Beach." Below, John and Katherine Kienzle are pictured with their daughter Mary on the beach in front of their home on Eighty-Eighth Street around 1915. The women's full Edwardian bathing costumes include hats, dresses, and stockings. (Both, RD.)

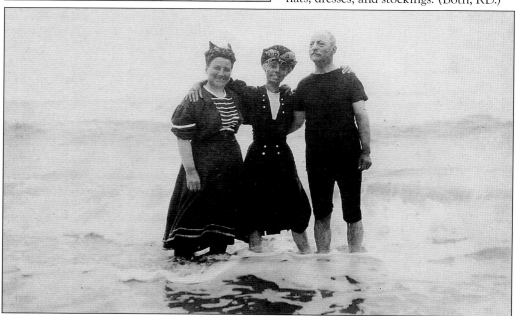

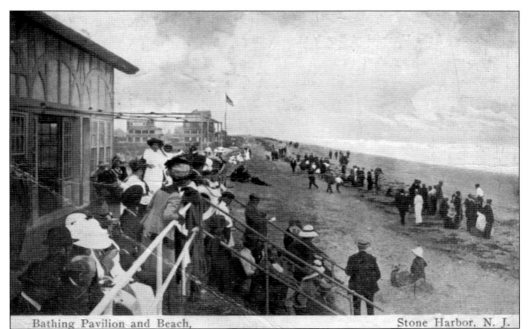

Bathing Pavilion and Beach, Stone Harbor, N. J.

Above is the beachfront bathing pavilion at Ninety-Sixth Street. Crowds gathered here to watch auto racing held directly on the hard-packed sand of the beach. According to *The Beach: The History of Paradise on Earth*, during the Middle Ages, bathhouses developed a reputation "as little more than dens of ill repute, where strumpets cavorted with wastrels, and the devil himself lurked in the red coals of brick ovens." But by the mid-1400s, regular bathhouses had become more respectable, and much of Europe embraced the use of these seaside therapeutic bathing facilities. At right, Dorothy Sayre, the sixth great-granddaughter of Aaron Leaming Sr., original owner of Seven Mile Beach, poses for a beachside picture around 1916. As residents of Cape May Court House, the family maintained close ties to the island even though they no longer owned it, closely following Stone Harbor's rapid development.

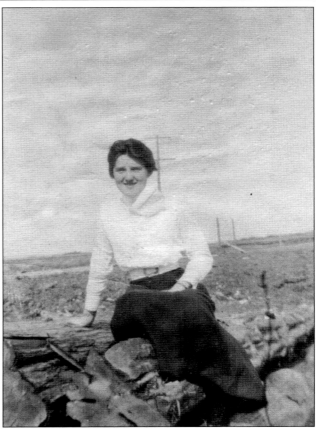

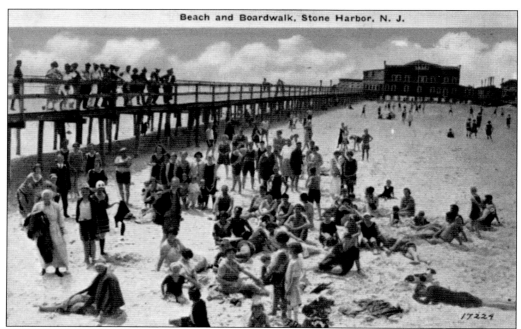

Beach and Boardwalk, Stone Harbor, N. J.

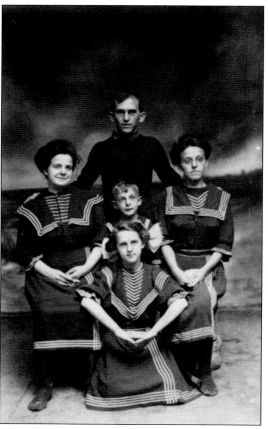

Stone Harbor's boardwalk was dedicated in 1916 and remained until it was destroyed by the Great Atlantic Hurricane of 1944. As described in *The Beach: The History of Paradise on Earth*, Impressionist paintings reworked the beach image into a "social place for visitors from the city, civilized and organized, where the body came into carefully monitored contact with the waves, and the rituals of domesticity prevailed over therapy. At the turn of the century, seaside life at the Jersey shore was a burlesque for the masses. Everyone was welcome, and the price of admission was the cost of a bathing suit." The boardwalk allowed people to stroll and socialize above the sand, yet still enjoy the cool ocean breezes. Stone Harbor's boardwalk was very much about status and social climbing, along with health, vanity, and fashion. At left, a family portrait from a boardwalk vendor commemorates a day at the beach.

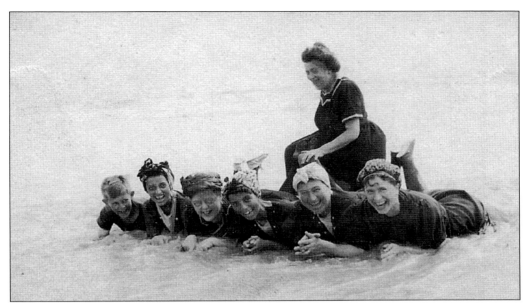

Above, members of the Kienzle family cavort on the beach around 1915, limited only by the heavy bathing costumes typical of the times. Constructed mostly of navy blue wool with spartan white trim, the costumes restricted physical movement to a minimum. Bathers would often gather in circles, holding hands to support each other as they jumped the waves in waist-deep water. They would turn their backs to the incoming waves and somersault forward as the wave rolled over them. At right, Mary Kienzle poses before taking a stroll on Stone Harbor's boardwalk, which offered lighting and railings for evening safety. (Both, RD.)

In the early 1920s, the beach and boardwalk were almost one entity. Many bathers preferred to sit in the shade of the boardwalk rather than out in the intense summer sun. Others enjoyed the cover of the pavilion where they could sit and watch the waves roll in while in relative comfort. A day at the beach was not complete without a photograph to document the fun in the sun.

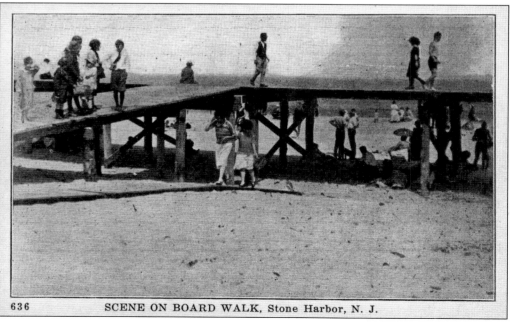

636 SCENE ON BOARD WALK, Stone Harbor, N. J.

The change from Edwardian bathing costumes to more unisex swimsuits in the 1920s offered far greater freedom of movement for men, women, and children. At right, Catherine (left) and Mary Fasy spent many summers with their grandparents John and Katherine Kienzle. They are seen at right on the beach at Eighty-Eighth Street in 1925. With the beach just a short walk away, swimmers needed nothing more than a towel and a bathing cap. The beach was for swimming, not sunbathing, so the group below did not need beach chairs, umbrellas, and the myriad of other beach paraphernalia that visitors currently drag to the water's edge. (Right, RD; below, SHM.)

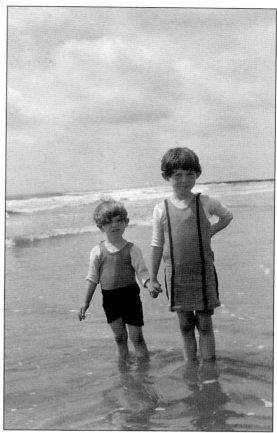

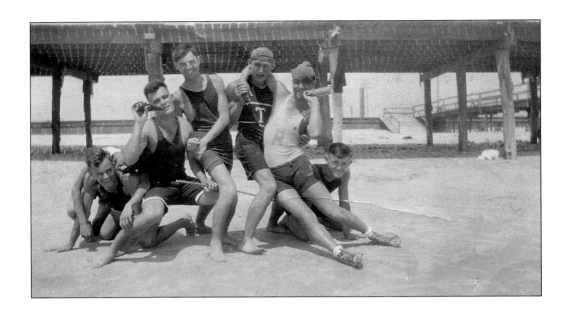

These groups of young men sport the "collegiate" swimsuits popular in the 1920s, consisting of body-hugging two pieces, yet still made out of wool fabric. It was the Jantzen Company that finally revolutionized swimwear material with a stretchy, ribbed jersey that provided a snugger fit than regular jersey and certainly more comfort than thick wool. Building a human pyramid was a popular practice and a good way to create an interesting photograph with which to memorialize a day on the beach. Note the boardwalk and pavilion in the background of both pictures.

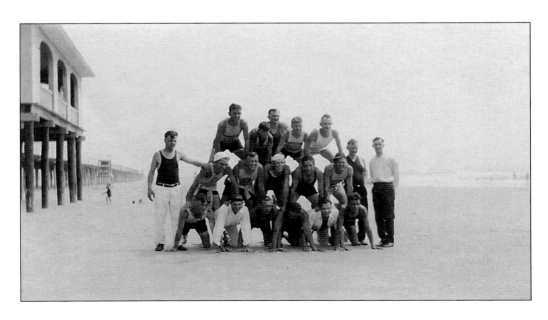

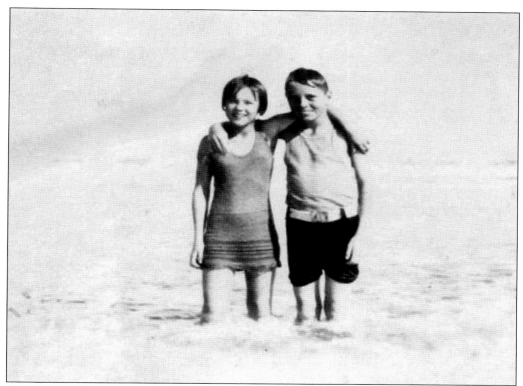

Ask anyone who has ever spent the summer in Stone Harbor, and he or she will surely confirm that friends made during the summer remain friends for life. Summer vacation at the Jersey Shore has always brought people from many geographic regions and walks of life together for long days of sun, sand, and memories. These pictures from the 1920s speak to the summer camaraderie that often grows into lifelong friendships. Many summer loves have begun with a chance meeting on the beach or the boardwalk, and long-term relationships have lasted long after the summer is over.

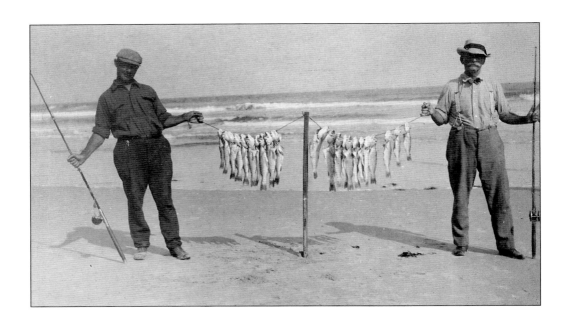

The beach was not just for bathing. Surf fishing off Stone Harbor's beaches has always been popular. In these photographs from around 1915, the John Kienzle family shows off a good day's catch. The 1907 *Prospectus* promises a "sportsmen's paradise." Kingfish, weakfish, drum, flounder, and sea bass were reportedly caught by the hundreds, and crabs, oysters, and clams abound on Stone Harbor's shoals. (Both, RD.)

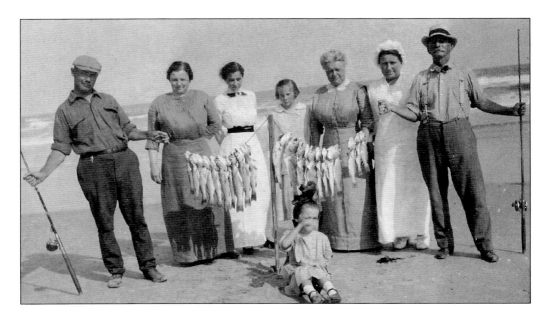

In 1928, a few fishing cottages dotted the Stone Harbor Ocean Parkway leading to the ever-growing resort community. Small beaches along the roadway provided access for fishermen and swimmers alike. Known as Scotch Bonnet, this area is prone to flooding and has suffered serious damage during hurricanes and coastal storms. The storm of 1962 floated many of the smaller homes off their foundations and left them sitting in the middle of the surrounding marshes when the water receded. In the above photograph, Jane Douglass (right) plays with an unidentified friend on one of the Scotch Bonnet beaches. Many families preferred to spend their time under the boardwalk, lounging and playing in the cooler sand, as Mary (left) and Catherine Fasy are seen doing in the 1925 photograph below. (Below, RD.)

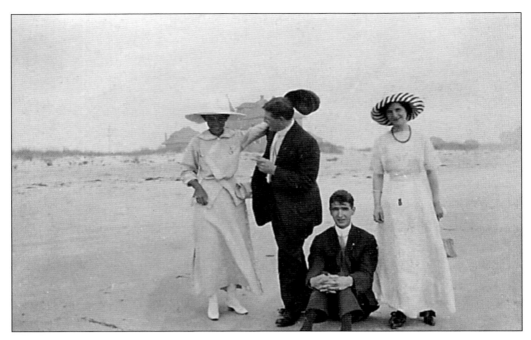

Above, Mary (left) and Charlotte Kienzle stroll Stone Harbor's beach with two handsome yet unidentified gentlemen around 1915. Dressed in what by today's standards would be considered formal attire, this stylish foursome gives evidence to the clear separation between bathing and beaching. Bathing suits were worn only for swimming and never to just take a walk or lounge on the sand. Hats for the ladies were a must, as sunscreen had yet to be developed and getting a tan was not yet considered fashionable. Suntans did not become fashionable until the 1920s. Below, Eleanor Pfeiffer poses in the dunes at the southern end of Stone Harbor. She and her husband, John, owned Pfeiffer's Department Store in nearby Sea Isle City. (Above, RD.)

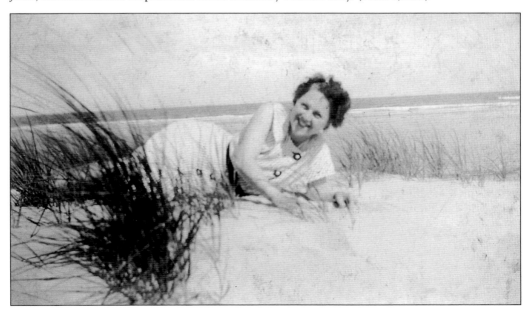

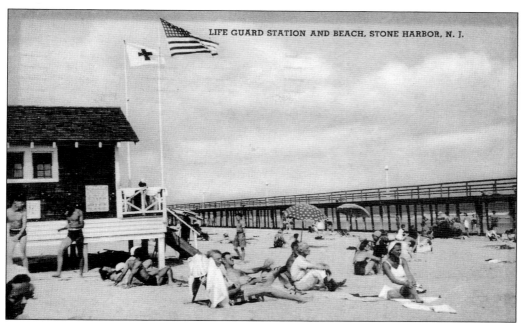

LIFE GUARD STATION AND BEACH, STONE HARBOR, N. J.

The Stone Harbor Beach Patrol was founded in 1916 by Cleon Krause, who, at age 16, worked for only tips. As the patrol expanded in the 1920s, a headquarters was built on the beach at Ninety-Fourth Street. Trained to standards set by the American Red Cross, the "surfmen" were equipped with cork-filled life belts and a surf reel—a giant spool of strong rope that could be thrown to a swimmer in peril.

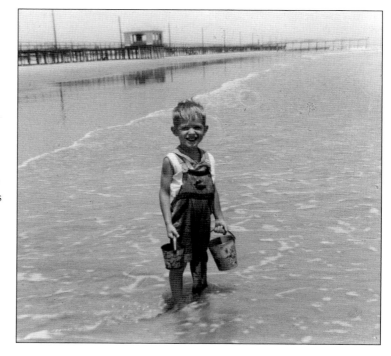

In 1941, Charles L. DuBois Jr. took to the beach, armed and ready with his sand pails. This wonderful photograph provides an excellent view of the boardwalk, pavilion, and fishing pier in the distance. His happy smile attests that DuBois is enjoying every minute of his visit to Stone Harbor. (SHM.)

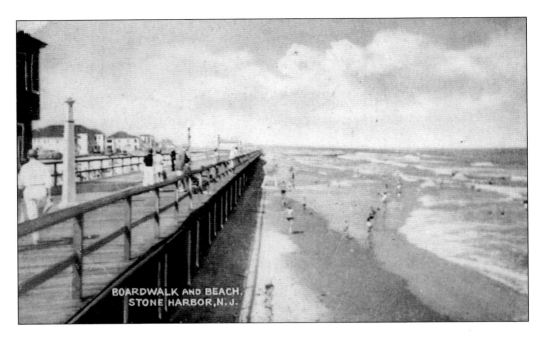

BOARDWALK AND BEACH, STONE HARBOR, N.J.

By the early 1940s, the beach had become a place to gather for far more than just a quick swim in the ocean. A day at the beach was now spent lying on a towel or blanket, hoping to get a tan, and periodically taking a dip in the water to cool off. Before medical professionals made the connection between sun exposure and skin cancer, tanned skin was a must for all beachgoers. Many a child was sent to the beach with instructions from their parents: "Go get some sun. You are looking peeked." A sunburned nose was worn like a badge of honor by many of the younger set lucky enough to spend the full summer in Stone Harbor.

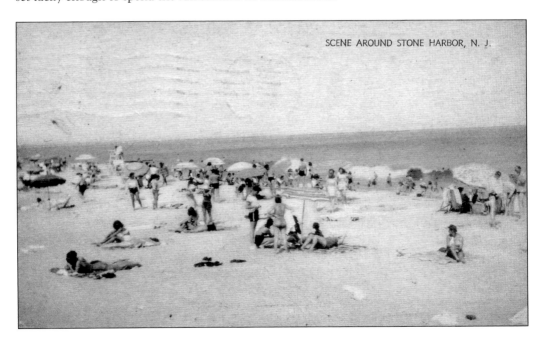

SCENE AROUND STONE HARBOR, N. J.

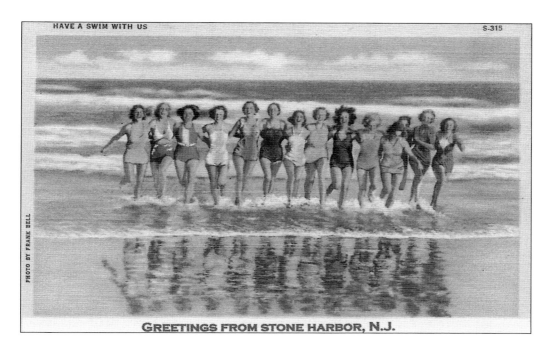

PHOTO BY FRANK BELL

GREETINGS FROM STONE HARBOR, N.J.

The swimwear industry was revolutionized in 1931 with the introduction of Lastex, which resulted in a whole new way of thinking about bathing suits. The Jantzen Company advertised swimsuits that were "super light, super soft [and] flex with every body movement like one's own skin!" By the late 1940s, bathers were no longer confined to just wading in the ocean waters and sitting on the beach; they could easily move and cavort, if wearing a stylish, colorful Jantzen swimsuit.

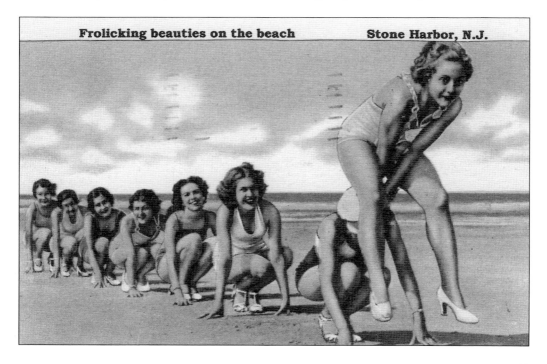

Frolicking beauties on the beach Stone Harbor, N.J.

The faces of these two young visitors express the feelings of thousands of children each year who are lucky to spend time on Stone Harbor's beaches. In 1930, Julius Way described Stone Harbor as the "Wonder City, [where] at no other resort in the world is there better ocean bathing, the strand gently sloping over three hundred feet from low to high water. It is an ideal vacation playground for all the family."

Jetties were constructed to stabilize the beaches and reduce sand erosion, but do not tell that to the scores of children who think they were built especially as a place to explore the ocean environment. Many an hour can be passed trying to find shells and starfish on and around the rocks, especially at low tide. (SHM.)

Stone Harbor's beaches are divided by eight jetties. These serve to prevent erosion and as homes for barnacles, algae, clams, and a wealth of other wildlife.

Over the years, Stone Harbor has worked hard to maintain the beauty of its beaches. Dune replenishment projects have been very successful in rebuilding beaches following storms and hurricanes. Recognizing the fragility of the beach environment, local residents join with borough officials each year to plant beach grass and erect storm fencing to stabilize the dunes.

Armed with nothing more than a sand shovel and a pail, children can play on the beaches of Stone Harbor, "the Seashore at Its Best." (SHM.)

At right, future author Donna Boss (Van Horn) plays on the beach at Ninety-Seventh Street, just north of the pavilion, in 1955. Below, Donna (left) is joined by her sister and future coauthor, Karen (Jennings), on the front porch of their great-grandfather's home in Cape May Court House as they get ready for a day on the beach in Stone Harbor in 1959. With just a four-mile drive, the heat of the mainland could be left behind. On many a summer night, the girls' parents, Jane and Carey Boss, would take the family to the beach for a cooling swim before bedtime, as their home built in 1895 was not air-conditioned.

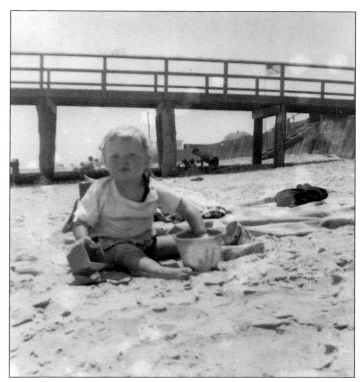

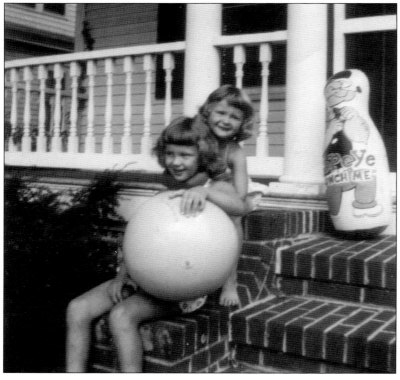

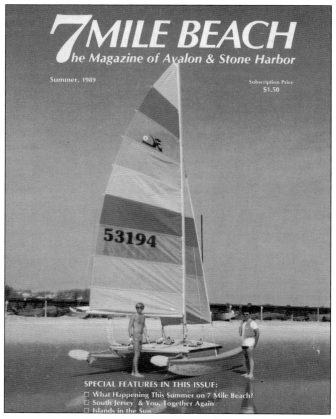

In the late 1960s, Hobie Alter, a surfboard manufacturer in Southern California, developed a lightweight, fast, and easy-to-sail playboat based on the Polynesian twin-hulled catamaran. In 1989, the cover of *7 Mile Beach* magazine featured what was becoming one of Stone Harbor's newest pastimes—sailing a Hobie Cat off the beach at 123rd Street. At left is longtime summer resident Charles Berger (left), ready for a sail. The borough began selling permits that allowed the catamarans to be staged on the beach in 1981. The gradual slope of the beach makes it perfect for launching these especially fast sailboats, and the fleet can be seen almost every weekend racing just offshore. Taken at the close of a summer season, the photograph below finds only a few boats remaining, awaiting storage during the cold winter months. (Left, CB.)

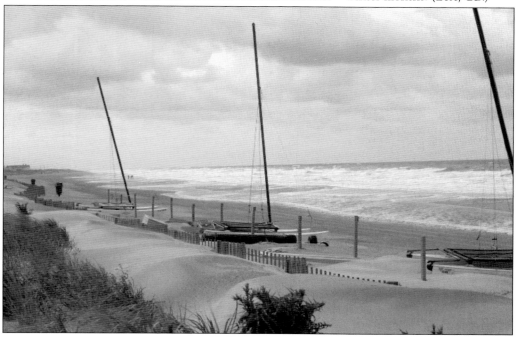

Another pastime that spread east from California is surfing. With beaches designated specifically for surfing, Stone Harbor was quick to join in the fun. The beach directly in front of the Villa Maria By-the-Sea, a retreat house for the sisters of Immaculate Heart of Mary, is host to the annual Nun's Beach Surf Invitational competition, which raises money for the home. Between sailing, swimming, fishing, surfing, and all the other beach activities, one in particular stands out. There is no better place for people watching and meeting friends than on the beach. When the Happenings recorded "See You in September" in 1966, they clearly knew what could happen during a summer at the shore. As the lyrics say, "Will I see you in September, or lose you to a summer love?"

What makes Stone Harbor so special is the family traditions that become established and continue from generation to generation. At left, future author Donna Boss (Van Horn) is pictured with her father, Carey Boss, on the beach in Stone Harbor in 1955. All that was needed for a day of fun at the beach was a sand pail. Fast-forward 33 years to 1988, and below is Donna's daughter, Ashley, on the same beach, also armed with her sand pail, just like her mother. Boxes of shells, souvenirs gathered by multiple generations of children, can be found in many Stone Harbor homes.

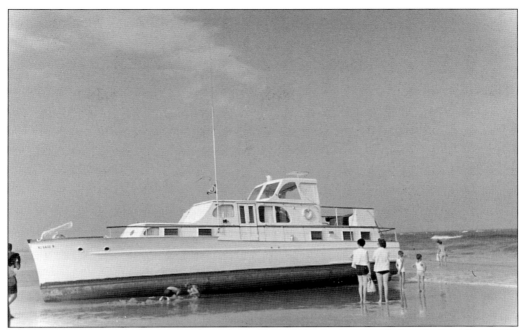

Imagine how surprised visitors were to find this large cabin cruiser stranded on the beach in 1960. While many boats have wrecked off the coast of Cape May County over the years, modern radar and navigational tools now make this an infrequent occurrence. (LCK.)

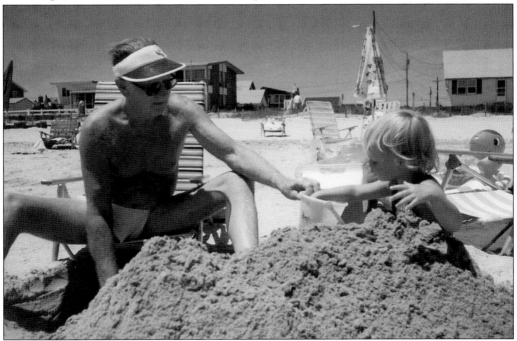

Carey Boss first perfected his sand castle skills in the 1950s and 1960s with his daughters, future authors Karen and Donna. Passing on the family tradition, he is pictured here on the beach at Eighty-Fourth Street with his granddaughter Sarah Van Horn in 1986.

These photographs are similar to those taken by thousands of Stone Harbor visitors to document their summer vacations. A picture in front of the lifeguard boat is a must for every visitor to the beach. At left is Bunny Morier in 1948, and below are sisters Ashley (left) and Sarah Van Horn in 1992 on Eighty-Fourth Street, where they spent their summers in their grandparents' home. (Left, LCK.)

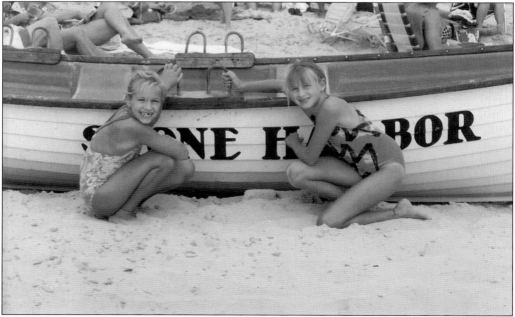

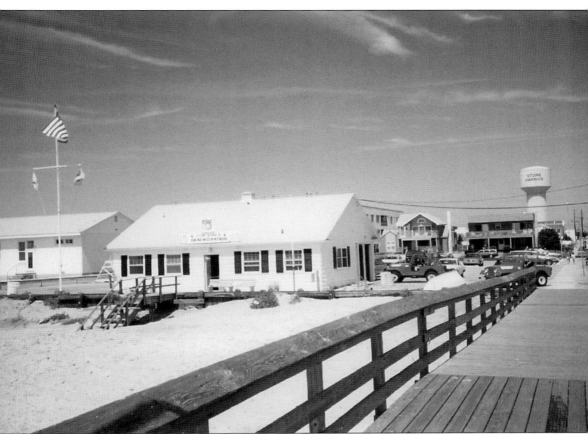

On the beach between Ninety-Fifth and Ninety-Sixth Streets stand two very important buildings impacting the safety and social health of Stone Harbor. The building at left is the home of the Women's Civic Club of Stone Harbor, founded in 1913. The original structure was destroyed by the 1962 storm, but rebuilt the following year. Organized to promote charitable and civic activities, the group sponsored and funded baby parades, tennis courts, beach pavilions, and landscaping. In the 1960s, teen dances were a much anticipated weekly event. The building at right is the headquarters of the Stone Harbor Beach Patrol. The iconic water tower at the corner of Ninety-Sixth Street and Second Avenue can be seen in the background.

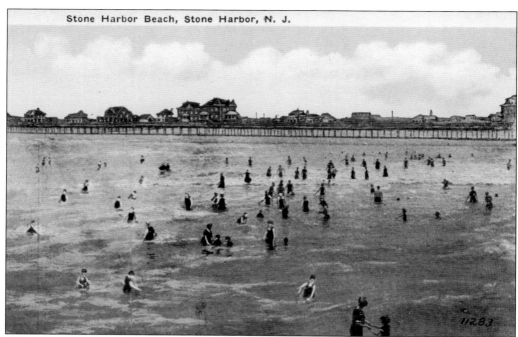

Stone Harbor Beach, Stone Harbor, N. J.

The view of Stone Harbor's beach has changed between the years that these postcard images were taken. Gone are the boardwalk and the cumbersome wool bathing costumes. What remains is a strong sense of family tradition. In fact, it may be the very absence of a boardwalk, and the amusements, noise, and crowds that go along with it, that helps to make Stone Harbor unique. The beaches are wide and clean, the water warm and gentle, and the breezes filled with the sounds of families returning generation after generation to "the Seashore at Its Best."

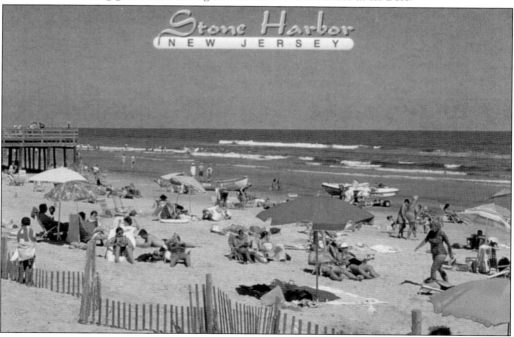

Stone Harbor
N E W J E R S E Y

Three

COME SAIL AWAY

At least two regattas were sponsored by the early Stone Harbor Yacht Club in 1895. On June 28, 1895, the *Star of the Cape* announced the following:

> Stone Harbor Yacht Race: There will be a "yacht race" at Stone Harbor, July 4th, the start will be made at 1 p.m. The course will be from the pier down the main channel to a stake boat at a point of Seven Mile Beach, to be sailed twice over. The race is open to all. Entrance free. The prizes consist of two silver cups and one silk flag. A number of entries have been made, composing the fastest yachts in the State, and designed by the best builders in the country.

Then, on August 9, 1895, the *Star of the Cape* noted the following:

> Stone Harbor Yacht Race: The second regatta of the Stone Harbor (N.J.) Yacht Club will take place Saturday Aug. 10th. The races are to be over a twenty-mile course, starting and finishing at the pier in Stone Harbor. The races are to be divided into two classes and the following yachts have already been entered: A.D. Edson's *Vim*, Captain Lewis Ludlam; Captain Geo. Jeffries' *J.A. Gault*, Captain Jeffries; Joseph Coleman's *Cornelli*, Captain Sayres; Horace B. Stevenson's *Minnia*, Captain Richard C. Holmes. The prizes are valued at over $100, and are said to be very handsome. The race of July 4th was so successful in every respect that the present contest excites interest throughout Cape May County, and the Yacht Club have spared no pains to insure a good time, and earnestly hope for a clear day and a three reef breeze.

Fourteen years later, in 1909, the Stone Harbor Yacht Club was officially incorporated for "the purposed of promoting interest in yachting and power-boating at Stone Harbor." Built by Larsen Contracting Company in 1910, the clubhouse was the focal point of the newly developing resort at its present location at Eighty-Ninth Street and Sunset Drive. After this club closed, the Yacht Club of Stone Harbor purchased the building and incorporated in 1929, continuing to be the center of social activity in Stone Harbor.

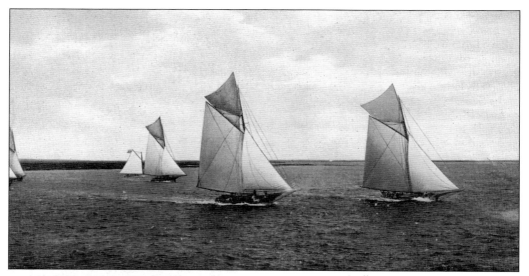

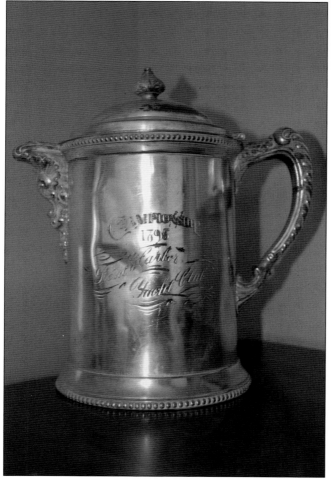

Sailboat racing under the name of Stone Harbor Yacht Club began as early as 1895. The first documented sponsored race included the following competitors: the *Ollivette*, owned by Charles McAllister; the *Alice*, owned by W.H. Pack; the *Vim*, owned by A.D. Edson; the *Harry*, owned by Frank Downs; the *J.A. Gault*, owned by George Jefferies; and the *Cornelia*, owned by Joseph Coleman. The June 28, 1895, edition of the *Star of the Cape* advertises a yacht race in Stone Harbor on July Fourth and details the course as "from the pier down the main channel to a stake boat at a point of Seven Mile Beach, to be sailed twice over." Open to all, "the prizes consist[ed] of two silver cups and one silk flag." From the authors' private collection, this trophy is inscribed with "Championship 1895 Stone Harbor Yacht Club."

George Sayres Jr. was the captain of the *Cornelia*, the boat owned by Joseph Coleman that is believed to have been the winner of the silver championship trophy in the previous picture. It is no surprise that he was an accomplished sailor. His father, George Sayres Sr., was captain of the Sea Isle City Life-Saving Station No. 33 from 1877 to 1883. George Jr. is pictured here with his granddaughter Eleanor Erricson, who went on to marry John Pfeiffer.

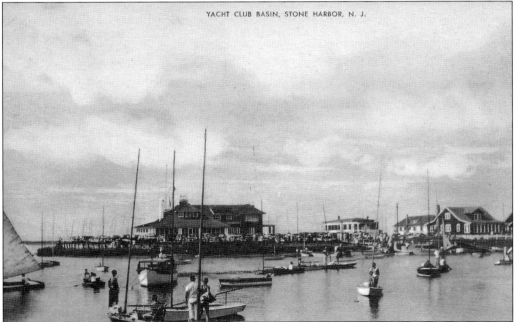

YACHT CLUB BASIN, STONE HARBOR, N. J.

This early postcard shows the high level of activity centered at the Yacht Club on a racing day. Sailboats fill the basin, waiting to head out into the channel and the established race course. Although boat ownership was not obligatory in order to become a member of the club, most members owned either sailboats or powerboats.

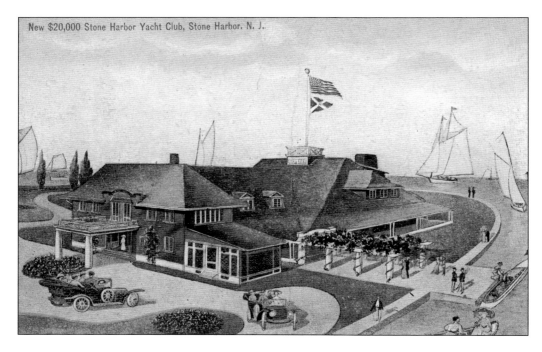

New $20,000 Stone Harbor Yacht Club, Stone Harbor, N. J.

This 1911 artist's rendering of the new Stone Harbor Yacht Club served as advertising for the resort. Text encourages tourists to visit either by boat or by train, and the cost of a day trip was only $1.65, as detailed below. At this time, train access to the island was either through Sea Isle City to the north or Wildwood to the south. A ferry ran every half hour from Cape May Court House on the mainland. The gaff-rigged yachts typical of the period are seen in the channel.

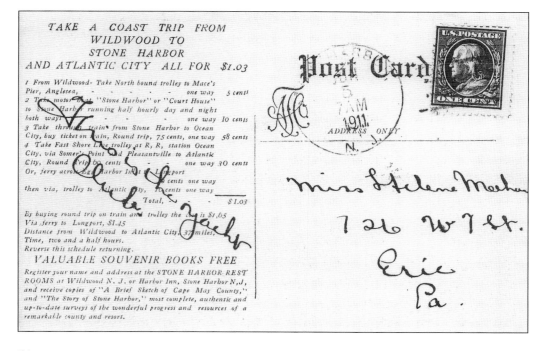

John Kienzle worked closely with the Risleys in promoting the establishment of the Stone Harbor Yacht Club. His daughter Charlotte is pictured at left in a catboat around 1915. Financial difficulties caused the Stone Harbor Yacht Club to close in 1921. A new group of investors purchased the long-vacant clubhouse in 1929 and reincorporated as the Yacht Club of Stone Harbor (YCSH). The postcard below shows the relatively marshy surroundings and minimal dockage on the channel side of the property. Two regattas were held in 1929, including the Gold Cup Power Boat Regatta, which became an annual event until 1941. On race days, the large flagpole would be lined with the burgees (flags) of the clubs of the visiting yachtsmen, as well as the club officers. (Right, RD.)

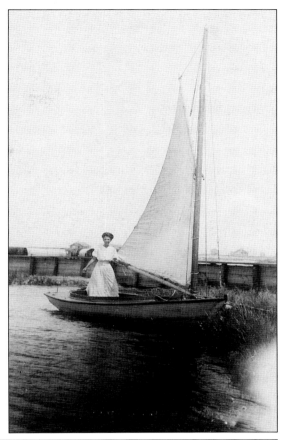

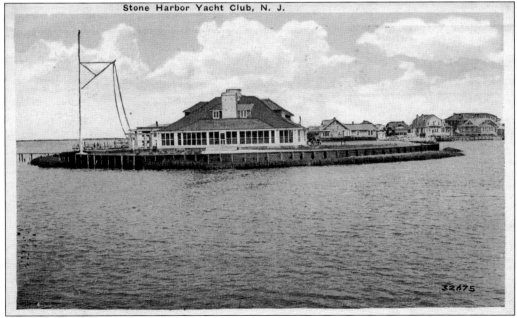

Stone Harbor Yacht Club, N. J.

32675

John and Katherine Kienzle pose on the beach at Eighty-Eighth Street before heading to Stone Harbor Yacht Club for a night's entertainment. (RD.)

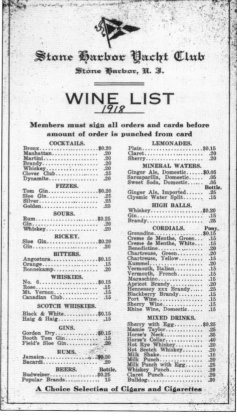

The early club was the center of social life in Stone Harbor. The grand ballroom was ideal for dancing. The restaurant was open daily, serving members who, according to an early club history, "wished to run down during the week or on Sundays—the duck shooting back of Stone Harbor being excellent in winter." This wine list from 1918 indicates a wide selection of alcoholic beverages, all available to assist in keeping members and their guests warm during the coldest of winter visits. (SHM.)

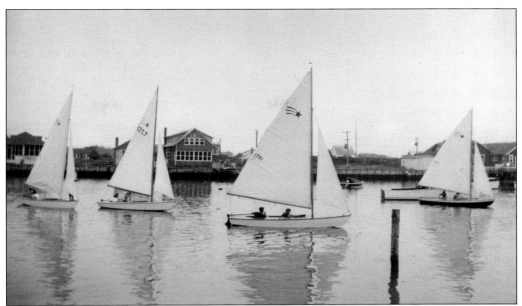

In 1932, a committee was appointed specifically to select a one-design boat that would be safe and efficient to sail in the ever-shifting waterways. The Comet, designed by C. Lowndes Johnson, had not only speed but also an adjustable centerboard ideal for senior and junior sailors alike. With the organization of the National Comet Association in 1934, YCSH was awarded Charter No. 1. By 1940, when the above picture was taken, the Comet had become the boat of choice for sailors of all ages in Stone Harbor. Race day was busy on both land and the water. Below, crowds of members and guests gather on the docks to watch the competition unfold. Comet No. 7 at far left was built by Herman Polhamus in 1934 and is now on display at the Stone Harbor Museum. (Above, SHM.)

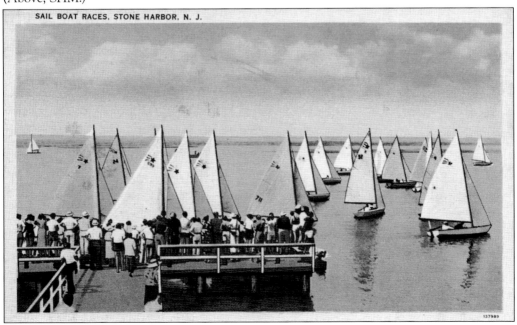

SAIL BOAT RACES, STONE HARBOR, N. J.

Bunny Morier is pictured at left on her Comet in 1948. George "Dob" Mehl and Brooke Suplee sailed their Comet, the *Comtesse*, and won the Summer Series races in 1948. The Comet became so synonymous with sailing in Stone Harbor that, for years, postcards always depicted the clubhouse with a Comet under sail. While the building itself might have undergone changes, such as new paint, windows, or flagpole, it was the Comet that remained the same year in and year out. (Both, LCK.)

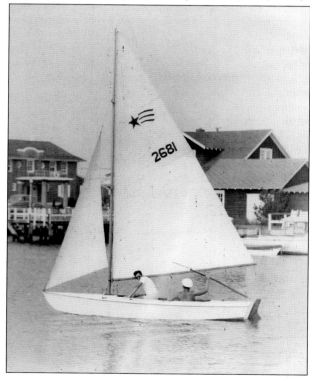

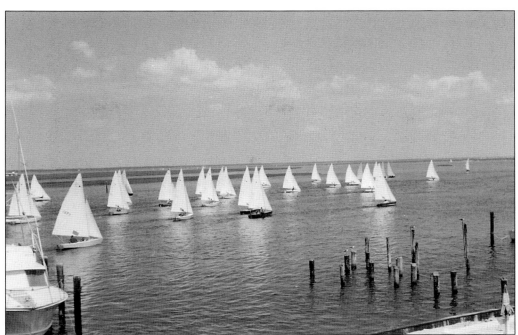

The start of a race for the Comet fleet was an exciting sight in the Great Channel in front of YCSH. This announcement for the 1956 Invitational Regatta shows the close cooperation between YCSH and the Borough of Stone Harbor. A sailing regatta is an activity that draws interest from the entire Stone Harbor community. Multiday events such as this yielded great benefits to the club and the community. Visiting yachtsmen and their families filled hotels, restaurants, and beaches when they came to race and often returned to Stone Harbor year after year.

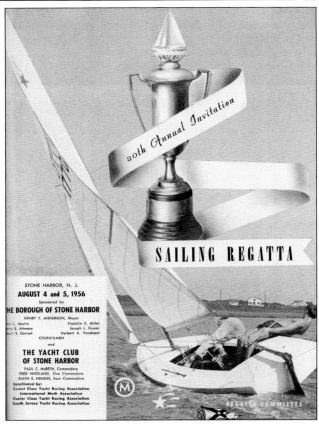

20th Annual Invitation

SAILING REGATTA

STONE HARBOR, N. J.
AUGUST 4 and 5, 1956
Sponsored by
THE BOROUGH OF STONE HARBOR
HENRY F. ANDERSON, Mayor
n C. Martin Franklin E. Miller
rry B. Altmore Joseph L. Guyon
rt S. Garrett Herbert A. Vandepol
COUNCILMEN
and
THE YACHT CLUB OF STONE HARBOR
PAUL C. McBETH, Commodore
FRED NIEDLAND, Vice Commodore
RALPH E. HENDEE, Rear Commodore
Sanctioned by:
Comet Class Yacht Racing Association
International Moth Association
Duster Class Yacht Racing Association
South Jersey Yacht Racing Association

REGATTA COMMITTEE

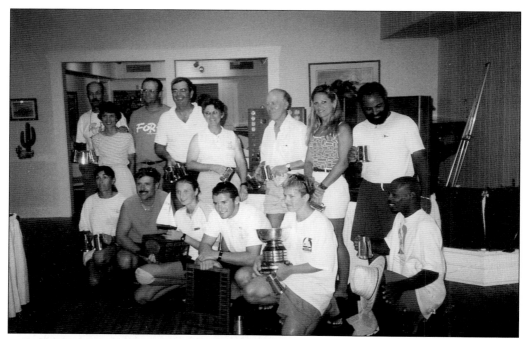

YCSH has hosted the Comet National Championships, Junior National Championships, and the International Championships in 1989, 1994, 1999, and 2002. Above are the winning skippers and crews from 10 fleets around the country and as far away as Bermuda who participated in the 1999 International Comet Championship. Skipper Steve Mehl and his crewman Sarah Van Horn of the YCSH are seen second and third from the left in the first row. They are holding the Eugene Barilla Trophy, awarded to the highest-finishing team from the host yacht club. The Comet International Perpetual Trophy is awarded to the winning skipper and crew at the close of the regatta. The winners' names are engraved on a plaque, and the skipper keeps the trophy until it is passed to the winner of the next international championship.

It takes teamwork to race a Comet. Stone Harbor sailors Sarah Van Horn, crewman, and Jake Mehl, skipper, proved to be a winning team, taking second place in the 1998 Comet International Junior Championships held at the Shrewsbury Sailing and Yacht Club in Oceanport, New Jersey. YCSH's traveling yachtsmen spend many hours each weekend trailering their boats from club to club, representing Stone Harbor in regular competition.

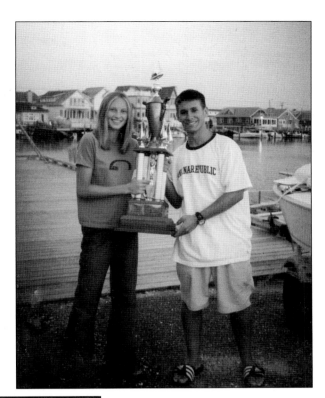

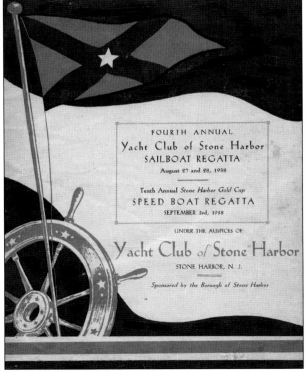

Powerboat racing began at the club in 1928 with the first Gold Cup Power Boat Regatta and continued until 1941. YCSH was the site of the 1931 New Jersey Motor Boat Championship Races and the 1936 National Championship Race for Inboard Motor Boats. This 1938 program shows the combined sailboat and powerboat regattas, once again jointly sponsored by YCSH and the Borough of Stone Harbor.

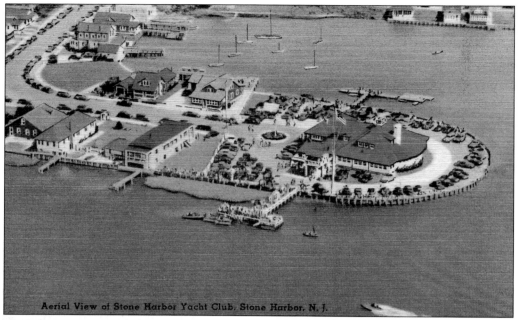

Aerial View of Stone Harbor Yacht Club, Stone Harbor, N. J.

This postcard shows a great aerial view of YCSH around 1940. Note the numerous sailboats anchored in the basin and the powerboats at the dock on the main channel. Both types of boats were happy to share the waters of the Intracoastal Waterway.

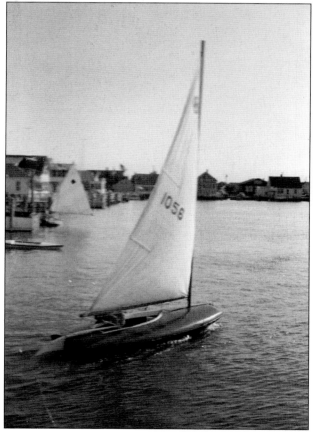

In 1948, YCSH organized its first Moth fleet, especially to entice children into sailing. By 1954, the fleet had grown to 34 boats, the largest on the East Coast, and was awarded Charter No. 17 by the International Moth Class Association. This photograph was taken in 1956. (LCK.)

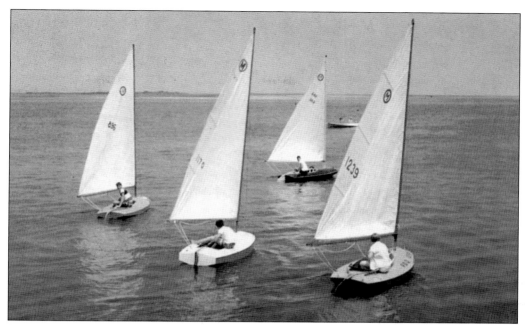

In 1929, Capt. Joel Van Sant of Atlantic City, New Jersey, started the American Moth Boat with his *Jumping Juniper*. The Moth has evolved from a hull that was a heavy, narrow scow or a blunt-nosed skiff (weighing about 50 kilograms) in the 1930s to today's remarkable foilers with hull weights of under 10 kilograms. In the 1960s, the back bays were often filled with Moths and their young skippers, participating in either daily group lessons or Wednesday and weekend races. YCSH sailors owned mostly Shelley, Ventnor, or Challenger Moths. Primarily, the Moth Class was intended to be sailed by a single skipper; but when the wind was strong, a smaller, younger child was often pressed into service as a crew strictly for extra weight. It paid to be small, limber, and light.

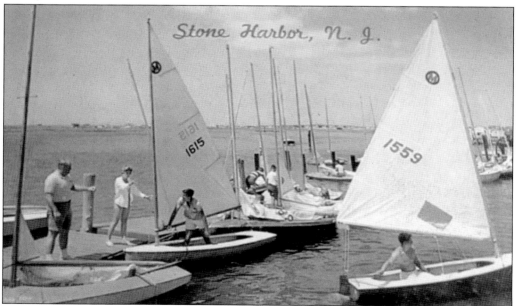

Designed by Jack Holt in 1949, the GP-14 could be cruised, raced, or rowed, or even powered by a small outboard motor. Its ability to be towed behind a small family car and launched and recovered relatively easily made this sailboat popular worldwide. In 1975, YCSH hosted the GP-14 World Sailing Championship Regatta, with entries from the United Kingdom, Canada, Ireland, South Africa, and Australia joining the US crews. The top-finishing local skipper was Jonathan Wright of YCSH, closely followed by his younger brother, Peter. John distinguished himself as one of YCSH's most accomplished sailors when he was part of the 1987 crew of *Stars & Stripes*, which successfully returned the America's Cup to the United States. He has since been inducted into the America's Cup Hall of Fame in Bristol, Rhode Island.

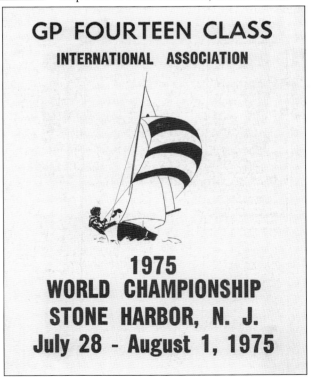

GP FOURTEEN CLASS
INTERNATIONAL ASSOCIATION

1975
WORLD CHAMPIONSHIP
STONE HARBOR, N. J.
July 28 - August 1, 1975

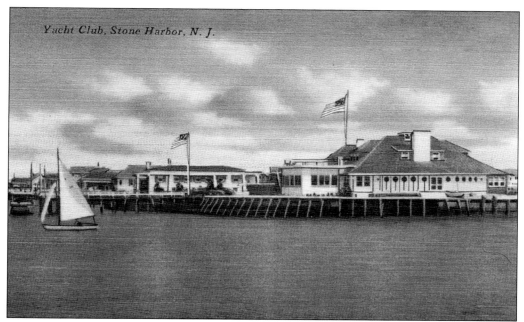

Yacht Club, Stone Harbor, N. J.

Prior to the start of each day of racing, a skippers' meeting is held at the clubhouse to review the rules and courses. A course map, such as the one below distributed in 1956, would be given to each sailor for reference while out on the water. Notice that, on this map, the races all begin and end at the clubhouse, making it easy for spectators to enjoy the action. Buoy No. 3, at the top right of the map, is located in what is known as the Dog's Leg. If the tide was high and the location of the sandbars was known, sailors could shorten some courses by sailing Muddy Hole Creek.

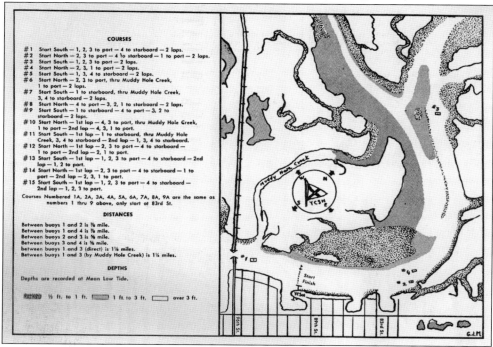

COURSES

#1 Start South — 1, 2, 3 to port — 4 to starboard — 2 laps.
#2 Start North — 2, 3 to port — 4 to starboard — 1 to port — 2 laps.
#3 Start South — 1, 2, 3 to port — 2 laps.
#4 Start North — 2, 3, 1 to port — 2 laps.
#5 Start South — 1, 3, 4 to starboard — 2 laps.
#6 Start North — 2, 3 to port, thru Muddy Hole Creek, 1 to port — 2 laps.
#7 Start South — 1 to starboard, thru Muddy Hole Creek, 3, 4 to starboard — 2 laps.
#8 Start North — 4 to port — 3, 2, 1 to starboard — 2 laps.
#9 Start South — 1 to starboard — 4 to port — 3, 2 to starboard — 2 laps.
#10 Start North — 1st lap — 4, 3 to port, thru Muddy Hole Creek, 1 to port — 2nd lap — 4, 3, 1 to port.
#11 Start South — 1st lap — 1 to starboard, thru Muddy Hole Creek, 3, 4 to starboard — 2nd lap — 3, 4 to starboard.
#12 Start North — 1st lap — 2, 3 to port — 4 to starboard — 1 to port — 2nd lap — 2, 1 to port.
#13 Start South — 1st lap — 1, 2, 3 to port — 4 to starboard — 2nd lap — 1, 2 to port.
#14 Start North — 1st lap — 2, 3 to port — 4 to starboard — 1 to port — 2nd lap — 2, 3, 1 to port.
#15 Start South — 1st lap — 1, 2, 3 to port — 4 to starboard — 2nd lap — 1, 2, 3 to port.
Courses Numbered 1A, 2A, 3A, 4A, 5A, 6A, 7A, 8A, 9A are the same as numbers 1 thru 9 above, only start at 83rd St.

DISTANCES

Between buoys 1 and 2 is ¾ mile.
Between buoys 1 and 4 is ¾ mile.
Between buoys 2 and 3 is ¾ mile.
Between buoys 3 and 4 is ½ mile.
between buoys 1 and 3 (direct) is 1⅛ miles.
Between buoys 1 and 3 (by Muddy Hole Creek) is 1¼ miles.

DEPTHS

Depths are recorded at Mean Low Tide.

½ ft. to 1 ft. 1 ft. to 3 ft. over 3 ft.

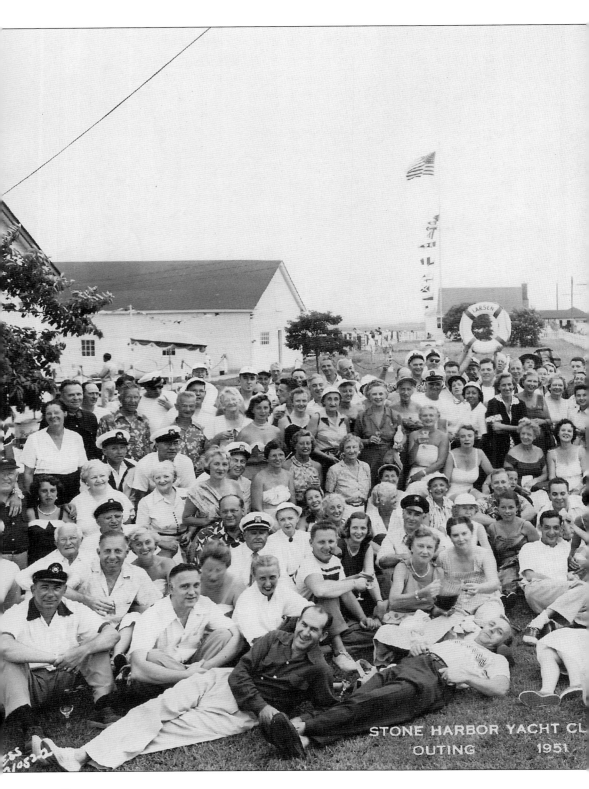

STONE HARBOR YACHT CL
OUTING 1951

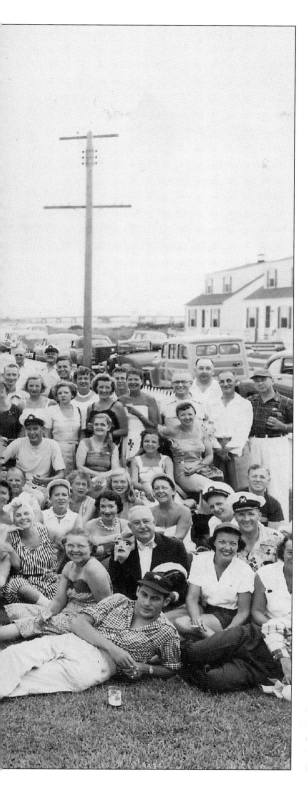

As a member of the Mid-Atlantic Yacht Racing Association (MAYRA), the YCSH has always been known for its very active social season. Dinner dances, theme parties, and day outings have long been a part of the summer schedule. Day trips include outings to New York City to see Broadway plays, crossings on the Cape May–Lewes Ferry, and Longwood Gardens. This photograph from 1951 documents a well-attended outing to a neighboring yacht club. With pitchers of drinks and champagne glasses in hand, the member of this group look like they are having a wonderful afternoon. (LCK.)

In the 1960s and 1970s, the Sailfish and Sunfish became the popular boats, especially for teenage sailors. Both boats were easy to rig, and although they had a tendency to overturn in heavy air, they could be righted with little difficulty by standing on the centerboard. When races were complete, the yacht club basin would be filled with Sailfish and Sunfish (hulls only), as sailors used them as swim platforms.

Cheetah Cat No. 31, built by Edme Deschamps in the 1960s and sailed here by Jay Corrigan, had a fixed teak deck rather than a trampoline. Only 21 were ever built, and they never sailed anywhere but at YCSH. A dedicated group of sailors kept this single fleet going until 2006, when most of the boats became just too old and costly to repair.

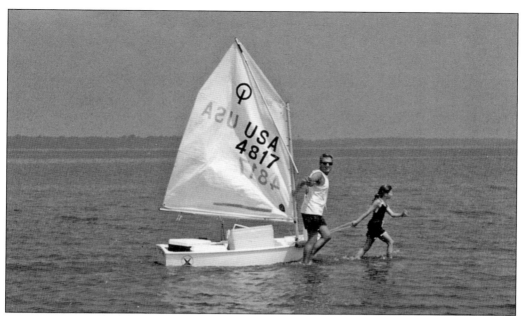

After years of teaching young sailors the rules of racing in wooden prams, the club updated to the Optimist dinghy in 1995. Above, race committee member John Van Horn and premiere sailor Beth Hendee use No. 4817 as a lunch delivery truck. Hendee won many state and regional championships and taught lessons for YCSH. She inspired and encouraged many young sailors to join the traveling sailing team. The YCSH travel team has long been a great opportunity for young sailors to test their skills against some of the best sailors on the East Coast. Below, participants in the Junior Olympic Sailing Regatta, held annually at Island Heights Yacht Club in Island Heights, New Jersey, show off their winning medals. The sailors are, from left to right, Maddie Jordan, unidentified, Toria Harr, two unidentified, Ashley Van Horn, Jake Harr, and Zack Harr.

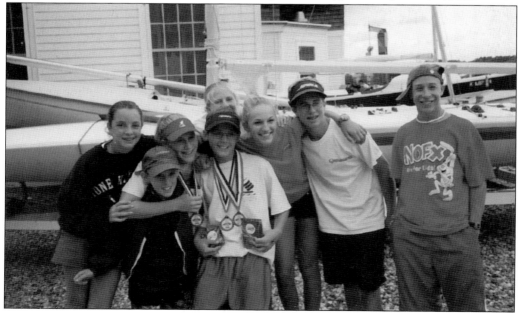

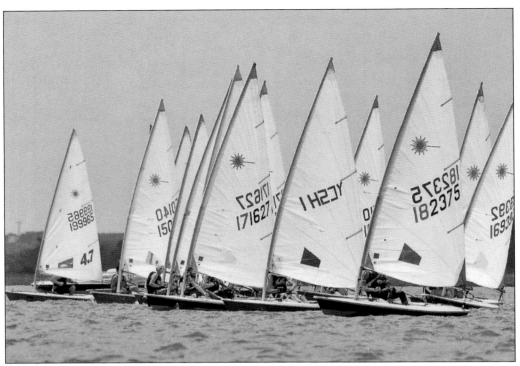

In the 1970s, the Laser made its first appearance at YCSH. Young sailors looking for a greater challenge than the Sunfish were making the switch to this very fast boat, designed specifically for speed and high performance. Sailing a Laser takes great skill and physical strength, as the boat is prone to tipping in heavy air. This picture was taken during the 2012 MAYRA Youth Invitational Regatta, hosted by YCSH.

Seeking a boat that offered the same level of regional competition as the Optimist, as well as the more social aspect of sailing with a crew, YCSH sailors Ashley Van Horn (left) and Toria Harr were instrumental in leading the establishment of the 420 fleet. A harness rig allowed the crew to "hike out" in heavy air, adding to the excitement of sailing this fast boat.

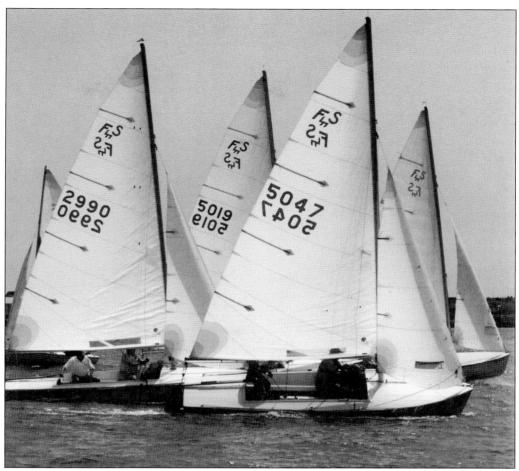

In 2005, YCSH sailors were looking for a boat design to replace the aging Cheetah Cats and Comets. Under the leadership of Bruce Nicholson, the club selected the Flying Scott as its newest fleet, which has changed the dynamics of sailing at YCSH. Flying Scotts are the perfect family day sailer and are actively raced in competition all over the United States. This fleet has grown rapidly, and in addition to weekend races in the Great Channel, a day of ocean racing against the fleet from Avalon Yacht Club has added to the level of competition. With their colorful spinnakers flying, the boats are exciting to watch as they race through the channel. (Right, LCK.)

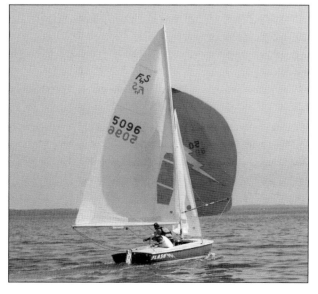

The Youth Activities Program (YAP) began in 1950. Since then, thousands have participated in arts and crafts or swimming and sailing lessons. The close of the summer season has long been marked with sailing and swimming races, with much coveted medals and trophies awarded for the many weeks of practice. In this picture from 1960, Thomas Keown, who went on to be a longtime Stone Harbor resident, real estate broker, and member of YCSH, proudly displays his six swimming medals. (TK.)

Growing up as part of the YCSH family often includes a summer job working there. Former YCSH students often return as instructors in the YAP program or wait staff in the dining room. In this photograph, Ashley Van Horn sells T-shirts at the annual Crab Night dinner.

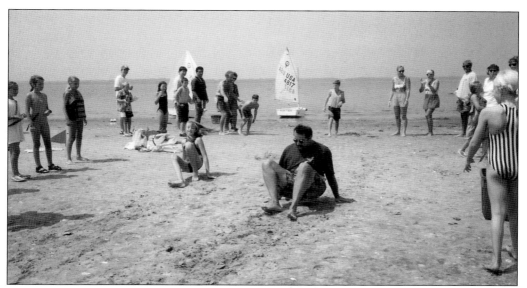

Off-site events such as family sails to Champagne Island in Hereford Inlet get club members of all ages involved, whether they travel by sailboat, powerboat, or Jet Ski. Relay races are always part of the fun, and this picture from 1994 captures the excitement of a crab race, with Gene Mopsick in the lead.

Little YAP is an activities program for preschool children. Daily arts and crafts and swimming lessons combine with games and lunch for the youngest YCSH members. Instructor Ashley Van Horn was a Little YAP participant herself 12 years before this picture was taken.

No history can overlook the contributions of George "Dob" and Mattie Mehl to the sailing program of YCSH. As chairman of the sailing program for more years than most can count, Dob began each race day with a skippers' meeting, reviewing the race rules and course for all sailors. Mattie and Dob would then hop on their boat, the *Blue Lady*, to set the racecourse, place the marks, and then start the races. After spending all weekend out on the water supervising the races, they could be found joining the crowd at the bar before dinner in the club. (Both, LCK.)

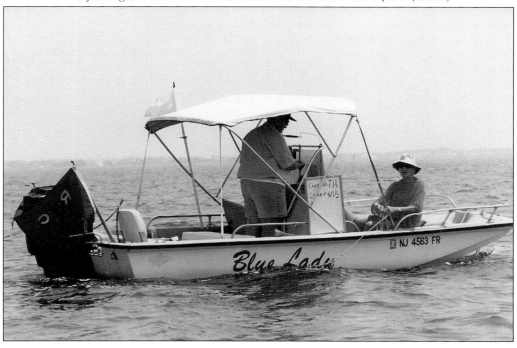

Pictured here at the annual Commodore's Ball, Mattie and Dob never missed a YCSH event and were dedicated in their support of the sailing program. Next only to their children and grandchildren, who also grew up at the club, they loved nothing more than YCSH. Mattie and Dob passed away just weeks apart in January 2014, but their presence at the club will long be remembered. (LKC.)

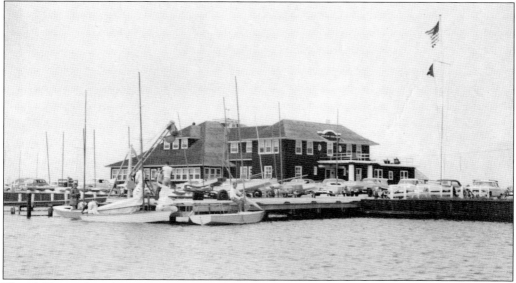

The clubhouse has changed since this picture in 1955. Apartments where summer staff boarded are now meeting rooms and storage space. The children's snack bar is now a casual dining room, and the docks have been reconfigured to accommodate the changing sailing fleets. The wooden canoe carved by longtime club manager Ad Beihling no longer hangs over the bar, but burgees from all over the world still top the windows. (LCK.)

What has not changed, and never will, is the sense of family history that is immediately felt upon entering the grand old building. With its beautiful polished wood floor and amazing views of the Great Channel, the main dining room has been host to thousands of parties, buffet dinners, and rock and roll nights. The most sentimental of these events is always the wedding reception of the son or daughter who grew up taking swim lessons, working, and sailing at YCSH. What better place to celebrate than the "backyard" in which so many wonderful summer days were spent? Sarah Van Horn and Mazen Yacoub did just that in June 2011. (Left, photograph by Andrew Graham Todes Photography; below, SHM.)

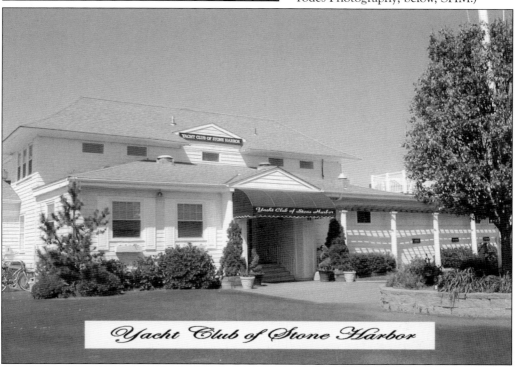

Yacht Club of Stone Harbor

Four

BAYFRONT BASINS

The old saying in real estate is "location, location, location." In developing Stone Harbor, the Risley brothers clearly knew this phrase and acknowledged that waterfront property would be at a premium. In their *Prospectus*, the Risleys describe the Great Channel as follows: "A course for yacht races or motor-boating, or as a fishing ground for those wishing to avoid the buffeting of the outer sea, it has no equal in the State. It would seem as though nature had especially shaped this beautiful beach for a pleasure park, affording in the fullest every opportunity for seaside sports."

Beachfront properties were limited in number, but these dreamers realized that by dredging basins open to the Great Channel, they could dramatically increase the number of waterfront lots. They state, "So great has the demand for lots near the ocean, that heretofore valueless meadows have been filled in, by means of hydraulic dredging, subdivide and sold at high prices." Without today's knowledge of the value of the natural marine environment and the need to preserve the meadows in order to sustain the area's natural wildlife, the Risleys developed a series of seven bayside basins, in addition to the single natural basin. The construction of South Basin (1908) and Snug Harbor (1909) created 142 "boathouse" lots, and 131 were distributed to bond holders in less than 60 days after the dredging had been completed.

Each basin has its own personality, some more commercial than others. North Basin, now known as Smuggler's Cove, is home to the municipal pier, condominiums, and boat fuel docks. Snug Harbor Basin is dominated by the Yacht Club of Stone Harbor's beautiful clubhouse. Shelter Haven Basin successfully blends residential with commercial properties, the newest of which is the Reeds at Shelter Haven Hotel. Stone Harbor, South, Pleasure, and Carnival Basins, along with Stone Harbor Hole, are strictly residential.

Bayside living includes crabbing, fishing, Jet-Skiing, boating, swimming from private docks, and, depending upon the location, views of gorgeous sunrises or equally magnificent sunsets. Thousands of visitors have come "down for the day for a dip in the bay."

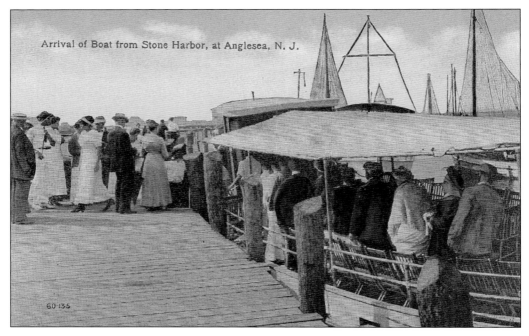

Arrival of Boat from Stone Harbor, at Anglesea, N. J.

60-135

Early visitors to Stone Harbor traveled by ferryboat, departing every half hour from Anglesea. Above, well-dressed visitors wait to board at the Eighty-Fifth Street Yacht Basin in the early 1900s. Below, Charlotte and Mary Kienzle are pictured in their own boat near the ferry. Notice the sign advertising "New Stone Harbor" in the upper left. As the development of Stone Harbor continued, the growing number of visitors increased the need for ferry transportation. Three ferries—the *Nellie Bly*, the *Florence W. II*, and the *Lottie W. II*—made daily runs bringing day-trippers and prospective property buyers by the thousands. The real Nellie Bly traveled around the world in 1889 in 72 days, 6 hours, 11 minutes, and 14 seconds, setting a world record. By naming a ferry after her, the owners implied a safe and speedy trip. (Below, RD.)

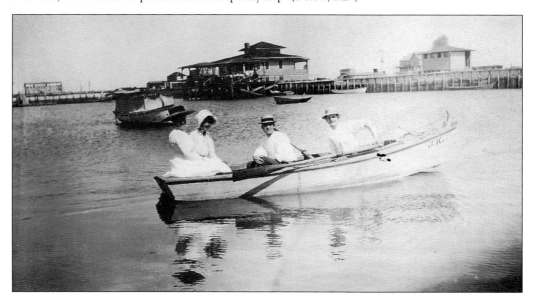

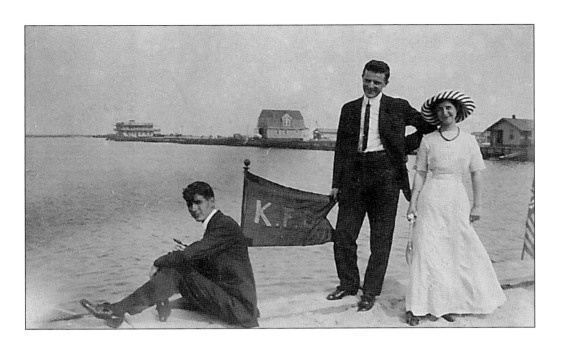

John Kienzle organized the Stone Harbor Fishing Club at Eighty-Sixth Street, just south of the ferry landing. In these lovely old photographs from around 1915, his daughters Mary (above) and Charlotte (below) head out for a day of fishing with friends. The nautical K.F.C. flag seen above stood for Kienzle Fishing Club. The Great Channel and its basins were full of flounder, weakfish, and drumfish, so rarely did a boat go out without returning with a healthy catch. (Both, RD.)

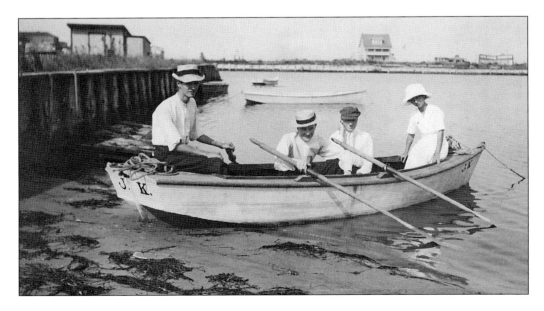

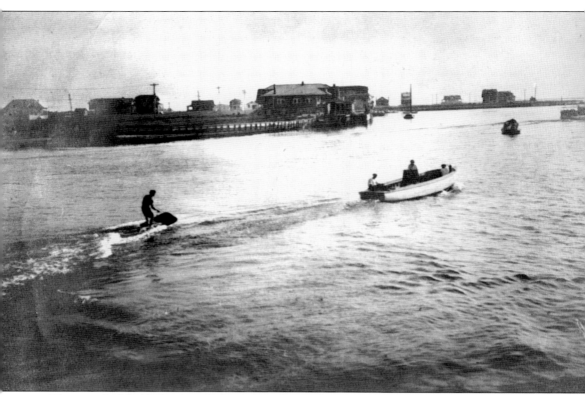

This wonderful old photograph from around 1920 shows an early form of wakeboarding behind a powerboat. In the upper right corner of the picture, one of the ferries can be seen cruising down the channel. Wakeboarding was not officially organized by the International Waterski Federation (now the International Waterski & Wakeboard Federation) until 1946, so this aquatic athlete was most certainly well ahead of his time. (RD.)

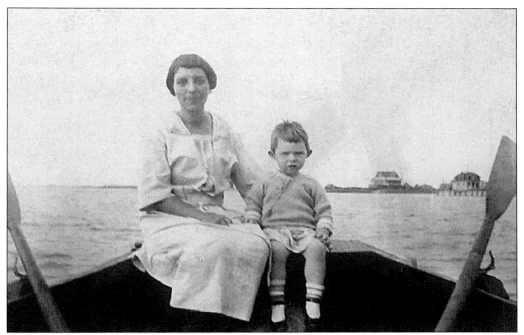

Charlotte Kienzle Fasy is pictured here with her daughter Mary, ready for a row around the Great Channel. The back bays of Stone Harbor have long been perfect for pleasure boating—whether powered by sail, oar, or motor. (RD)

The original North Basin, between Eighty-First and Eighty-Third Streets, was renamed Smuggler's Cove in 2007. The view in this 1947 postcard is not much different from today, except for the vintage boats. The three-story building at left was Guyon's Pier, now Smuggler's Cover Marina, great for gassing up the boat, stocking the bait box, and buying fishing tackle.

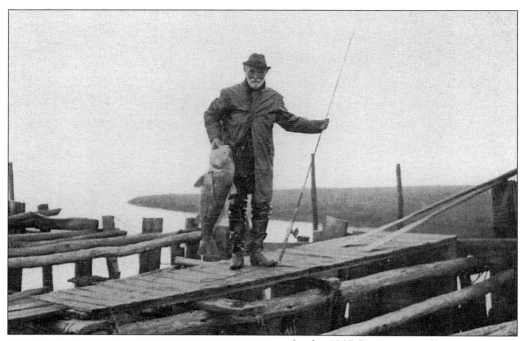

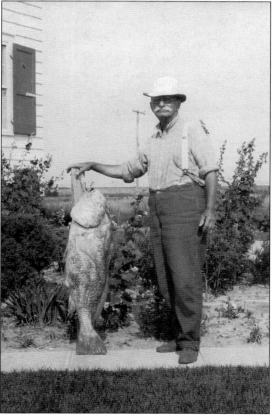

In the 1907 *Prospectus*, Jefferson Justice of the auditor's office for the Pennsylvania Railroad is touted as an "expert angler," with the above image of him holding a 48-pound drum fish. Not to be outdone, John Kienzle shows off his drumfish catch at left in 1925. The world record weight for a drumfish is 113 pounds, so although large, these two fish fall far short of that record. Sometimes found in or near brackish waters, larger, older fish such as these are more commonly caught in the saltier areas of the bay, near the inlet and oyster beds or other plentiful food sources. (Above, CP; left, RD.)

John Branin Douglass, showing off his bluefish catch in 1964, spent his life fishing the back bays of Stone Harbor. Known to his friends as "Skate," he is memorialized in the 1972 fishing column Tight Lines as follows: "Farewell old friend – our life was made better by your presence. May you rest in peace and enjoy that place in that Fisherman's Heaven with the rest that have gone before you."

South Basin was the first man-made basin dredged in 1908. Below, Thomas Keown stands on the southern side of the basin in the 1950s. These waterfront building sites offered easy access to boating, fishing, crabbing, and swimming. Tom's family still lives on this basin, in a home almost directly behind were he stood all those years ago. (TK.)

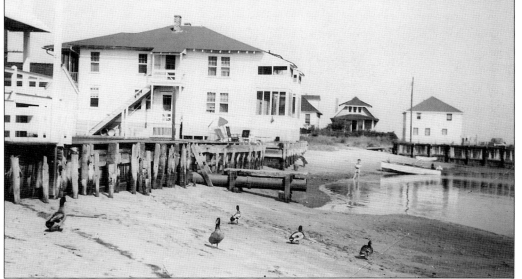

Looking north within South Basin, this view shows some of the Shelter Haven home models built in the 1960s, many of which can still be found all over Stone Harbor. The layout of these homes was perfect for casual summer living, with a bedroom on the first floor and two additional bedrooms off a second-floor loft. (TK.)

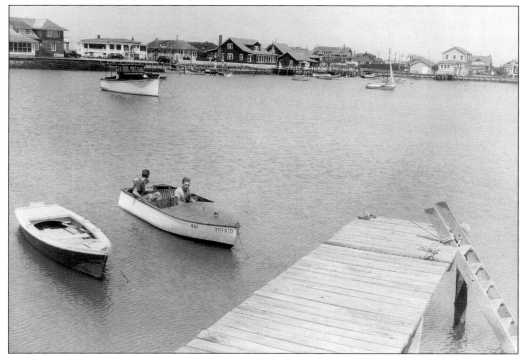

Snug Harbor was dredged in 1909 and became home to the Stone Harbor Yacht Club shortly thereafter. In this photograph from the 1940s, YCSH appears at far left. The large white stucco home to the right of the clubhouse was torn down in 2006, but the dark-brown house, built in 1930, still stands immediately next to the club's parking lot.

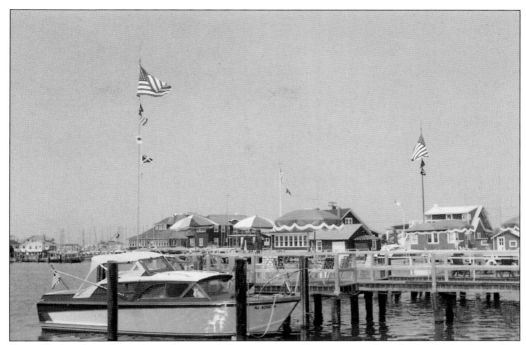

Snug Harbor has always been busy with boat activity. Since it was first dredged, this basin has been the center of pleasure boating, whether sailboats readying for a race or powerboats out for a cruise. The basin is well protected from the weather and deep and wide enough for larger yachts to freely maneuver. These photographs from the 1960s offer a peek at what vacationing on Snug Harbor was like and how boating was at the heart of that lifestyle. (Both, LCK.)

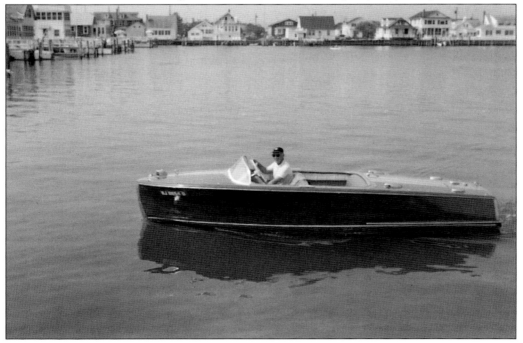

Dredged in 1910, Shelter Haven Basin has become a combination of commercial and residential properties over the years. In the image below, the large white building at center is the Shelter Haven Hotel, which was built in 1912. Although the postcard, mailed in 1934, shows a happy group swimming in the basin, the message it relays is not so cheerful. The writer notes, "Our vacation has not been very pleasant as to weather, but perhaps have had more rest on that account." Fortunately, Stone Harbor has always offered a variety of rainy-day activities to keep vacationers occupied.

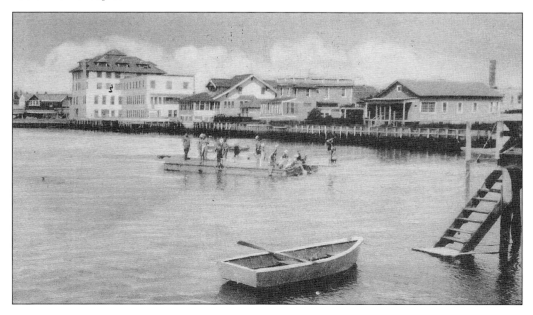

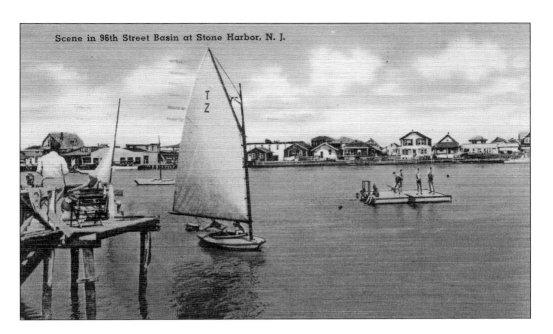

Scene in 96th Street Basin at Stone Harbor, N. J.

Both of these postcard views of Shelter Haven Basin were mailed in 1953. Boating, sailing, and swimming were obviously popular pastimes for these families lucky enough to have properties along the basin. The back bay waters are always warmer than the ocean and, with no wave action, much more suited to swimming. The swim platform in the middle of the basin was anchored there for the summer, and on any given day, dozens of local youth could be found swimming and diving from it. Fishing and crabbing from the docks was also a great way to ensure a fresh seafood dinner.

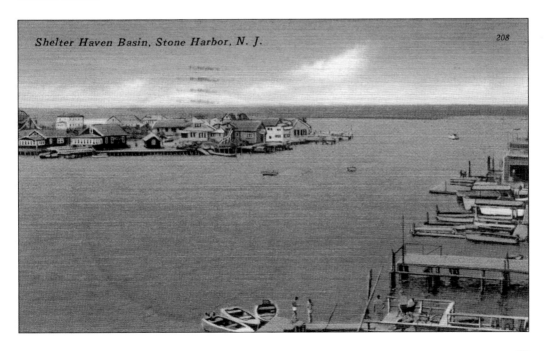

Shelter Haven Basin, Stone Harbor, N. J. 208

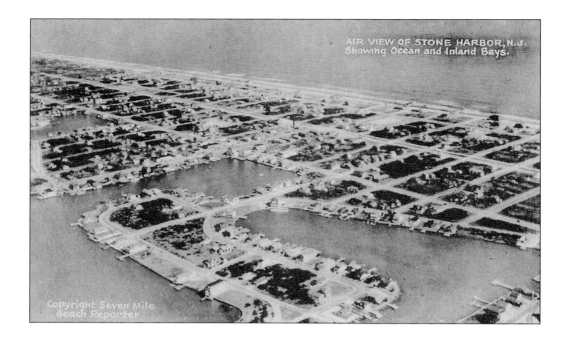

In 1930, Julius Way provided the following description: "Seven tide-water bays, connecting with the inland waterway, indent the westerly side of the town, each covering from two to twelve acres, where every known water sport can be safely enjoyed. It is an ideal vacation playground for all the family." A comparison of aerial views from the late 1930s and 1959 gives evidence to the rapid development of the waterfront properties. A message on the postcard below notes, "Having a swell time . . . the weather here has been swell."

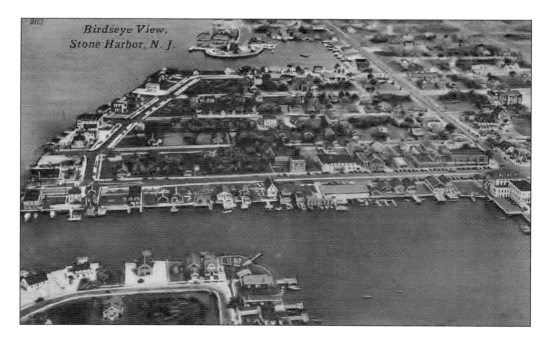

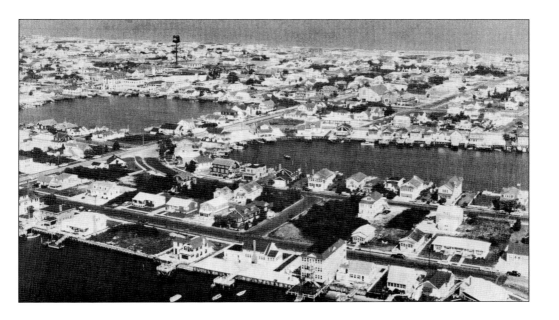

Although mailed in 1964 and 1972, these aerial postcard views must have been photographed prior to 1961, when the Shelter Haven Hotel was demolished, as the large structure can still be seen at the corner of Ninety-Sixth Street and Third Avenue, where it had stood since 1912. It was the largest building in town, and many of the guest rooms had views of the Shelter Haven Basin. That corner is now home to the Reeds at Shelter Haven, a 37-room hotel, restaurant, and bar.

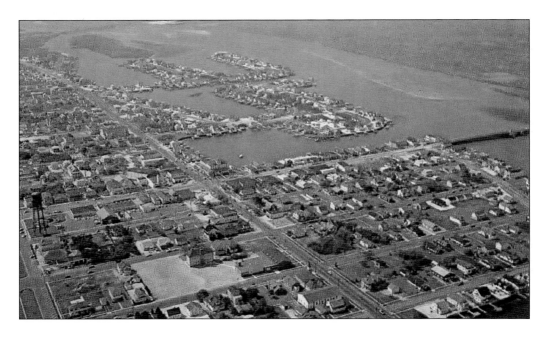

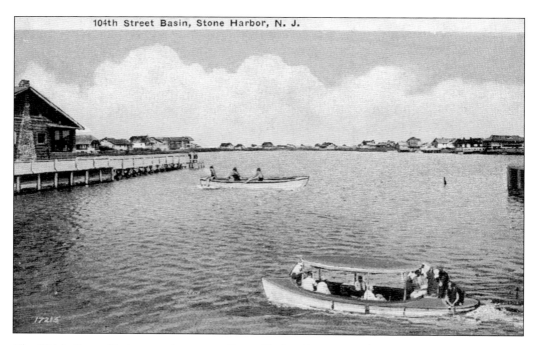

104th Street Basin, Stone Harbor, N. J.

The 104th Street Basin, now known as Stone Harbor Basin, was the only natural basin, and as its original name suggests, it was bordered by 104th Street to the south. A small bridge leads to Carnival Bay on the southern side of the street. Large, wide, and deep, this basin has long been a favorite not only for those who have homes along its waters but for also boaters who often anchor in the basin for an afternoon of swimming and sunning in quiet, calm waters. On the postcard below from 1952, the sender notes, "What a place . . . nice little town . . . nobody wants to go home!"

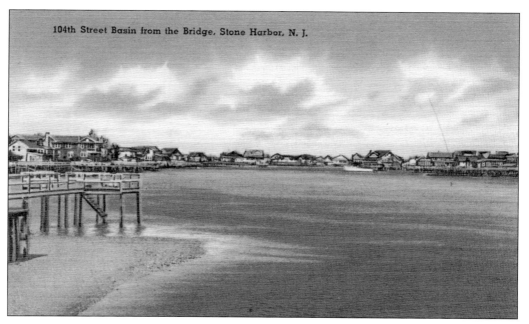

104th Street Basin from the Bridge, Stone Harbor, N. J.

In 1960, young Charles Berger had already discovered the great fishing in the basins of Stone Harbor, where he spent many summers at his parents' home on Eighty-Fourth Street. Posing with two nice size flounder, he looks "hooked" on the summer fun to be had in Stone Harbor. Flash-forward to 2014, and Charles and his wife, Cheryl, are still enjoying their summers in Stone Harbor, only now from their own home on Stone Harbor Basin. Traveling every weekend from suburban Washington, DC, the Berger family joins in the fun of fishing, kayaking, Jet-Skiing, and boating off their basin dock. (Above, CB.)

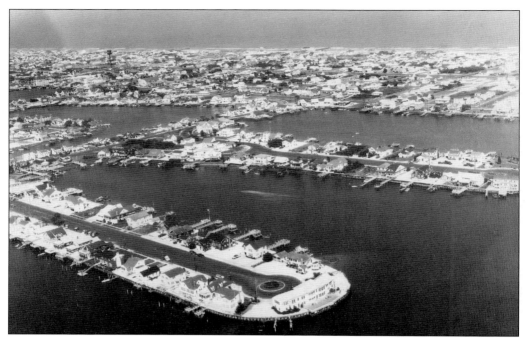

Lying south of 104th Street are two large basins that parallel the Great Channel. With Pleasure Bay to the west and Carnival Bay to the east, this area of town has always been quiet and devoid of traffic, as Golden Gate Road dead-ends at the mouth of the basin. The palatial white house on the circle at the end of Golden Gate Road was home to the Clark family for many years and has since been torn down to make way for an equally large, modern home. The views from this location are spectacular, filled with natural marshes and colorful sunsets.

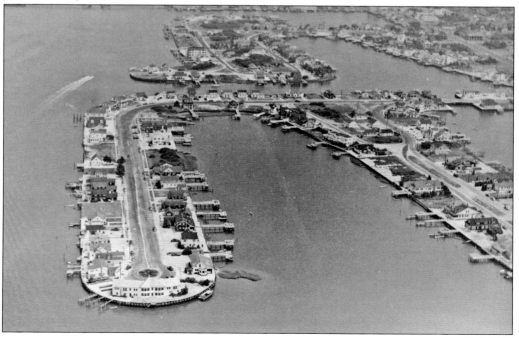

The Harr and Doan families have long had homes on Stone Harbor Hole. Many a party has seen their children and grandchildren diving into the water from their docks. Not all have been as brave as Christen Goodby (left) and her neighbor Toria Harr, who are seen here jumping from the back of the railing.

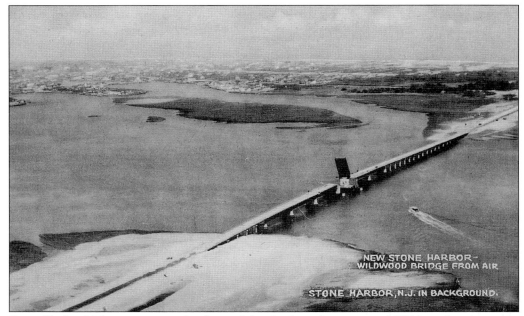

NEW STONE HARBOR-
WILDWOOD BRIDGE FROM AIR

STONE HARBOR, N.J. IN BACKGROUND.

Stone Harbor Hole gives way to the channel that leads to the ocean and Wildwood to the south. The Free Bridge connects the tidal islands that are home to a great variety of migrating birds.

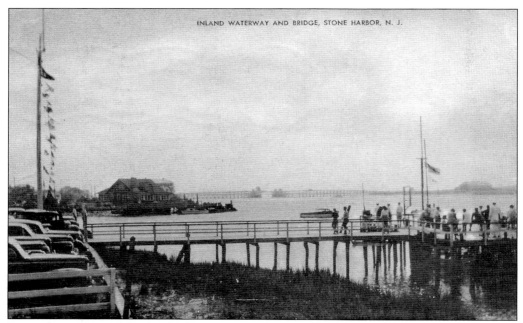

It was the opening of the first bridge at Ninety-Sixth Street in 1911 that ultimately endured the successful development of Stone Harbor. Easy access to the mainland through the extensive salt marshes and over the Great Channel brought the island to life. The Stone Harbor Boulevard Bridge can be seen in the background of this 1940s postcard. Below is the Free Bridge that connects the southern end of Stone Harbor to an undeveloped marsh island leading farther south to Wildwood. This marsh area is a popular location for birders who come to watch ospreys, white egrets, blue herons, and seagulls feed and nest undisturbed by automobile traffic.

Five

SHOPPING NINETY-SIXTH STREET STYLE

Fifth Avenue, New York, New York; Rodeo Drive, Beverly Hills, California; Worth Avenue, Palm Beach, Florida—all are addresses synonymous with high-end shopping and style. Add to that list Ninety-Sixth Street in Stone Harbor. Successful shopping meccas do not just happen. They take careful planning to create an area where people want to travel and spend their time and money. The Risleys truly were visionaries whose dream of a resort community with a centralized downtown shopping district was far ahead of its time.

In the 1960s, respected author and urban planner Jane Jacobs identified cities as living beings and ecosystems. She suggested that, over time, buildings, streets, and neighborhoods function as dynamic organisms, changing in response to how people interact with them. She explained how each element of a city—sidewalks, parks, neighborhoods, government, and economy—functions synergistically, in the same manner as the natural ecosystem. She advocated for mixed-use development—the integration of different building types and applications, whether residential or commercial, old or new.

Stone Harbor's primary shopping district, centered along Ninety-Sixth Street, epitomizes just that balance between old and new, residential and commercial. There is a wonderful blend of businesses, supplying everything from life's daily necessities to high-end luxury items. Groceries, books, beach supplies, and hardware share space in the stores with jewelry, resort wear, and evening clothes. Restaurants, bars, and snack shops are interspersed with miniature golf and arcade games.

This vibrant shopping district exists because the Risleys recognized that even though Stone Harbor was planned as a resort community, people who chose to make their permanent homes here would need more than just souvenir shops. If a family were to arrive for a week's vacation without any luggage, they could fully stock their refrigerator and closets with one simple trip to Ninety-Sixth Street. While businesses have come and gone, adjusting to meet changing tastes and style, others remain as throwbacks to a simpler time. As true a main street as one can find, Ninety-Sixth Street is the heart of Stone Harbor.

This early advertising postcard shows the special Pennsylvania Railroad car that brought potential investors on free inspection outings to newly developing Stone Harbor.

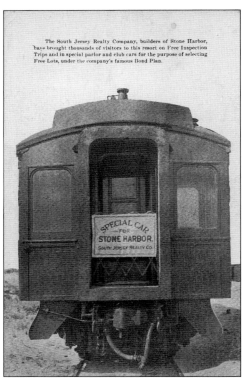

The South Jersey Realty Company, builders of Stone Harbor, have brought thousands of visitors to this resort on Free Inspection Trips and in special parlor and club cars for the purpose of selecting Free Lots, under the company's famous Bond Plan.

SPECIAL CAR
—FOR—
STONE HARBOR.
SOUTH JERSEY REALTY CO.

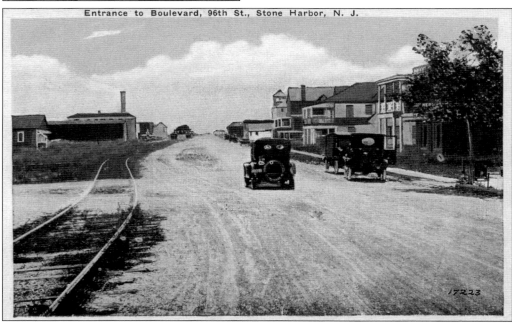

Entrance to Boulevard, 96th St., Stone Harbor, N. J.

Once the bridge and parkway were open, it did not take long for development to boom. Automobile traffic replaced the trains, as can be seen by the grass growing on the unused tracks in this early postcard. The center of Stone Harbor's development had shifted from near the Eighty-Third Street train station to Ninety-Sixth Street and the parkway entrance to town.

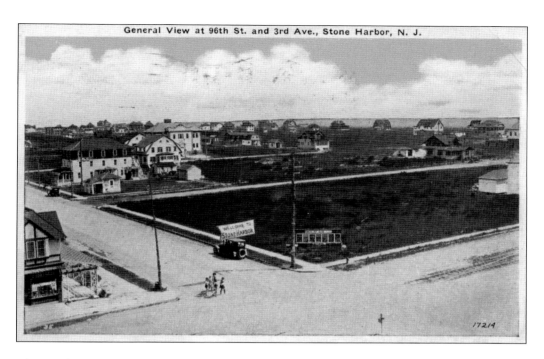

These early images show the ever-increasing development of Ninety-Sixth Street and the remnants of the train tracks leading to the bridge. The three-story brown-and-white building seen above was the Duval Hotel and still stands as home to the infamous Springer's Ice Cream. No visitor to Stone Harbor leaves without standing in line at least once at Springer's. In the left corner is the Seaman & Letzkus store, one of the first businesses established on Ninety-Sixth Street. The owner, Clarence O. Letzkus, served as the borough's first clerk.

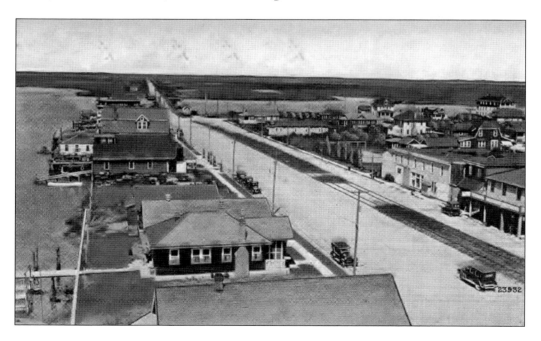

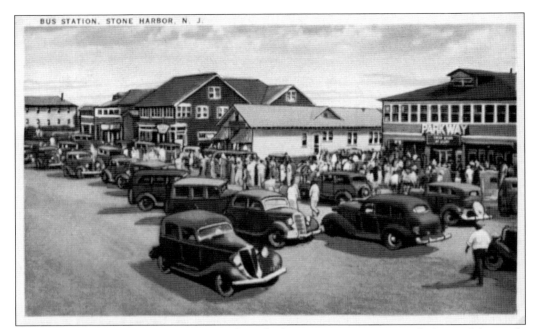

BUS STATION, STONE HARBOR, N. J.

This postcard from the 1930s shows crowds at the bus station competing with those of the newly opened Parkway Theatre, adding to the vibrant atmosphere of the town's main thoroughfare. Americans were in the middle of a love affair with their automobiles and the mobility they brought to everyday life, and day-trippers clogged the street, fighting for a place to park.

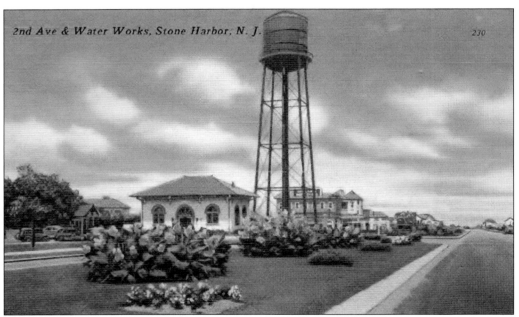

2nd Ave & Water Works, Stone Harbor, N. J. 230

This view shows the beautiful island gardens that stretch along Second Avenue, intersecting Ninety-Sixth Street at the waterworks. The chamber of commerce first planted and maintained the island garden that greeted visitors to Ninety-Sixth Street in 1940. The plantings are lovingly maintained by volunteers from the garden club.

Troxel's, 96th and 2nd Ave., Stone Harbor, N. J.

Troxel's Variety Store sold everything from candy to housewares. David Troxel left a huge mark on the history of Stone Harbor when he commissioned postcards of the town to sell in his store. The historical record left behind in those images is unparalleled.

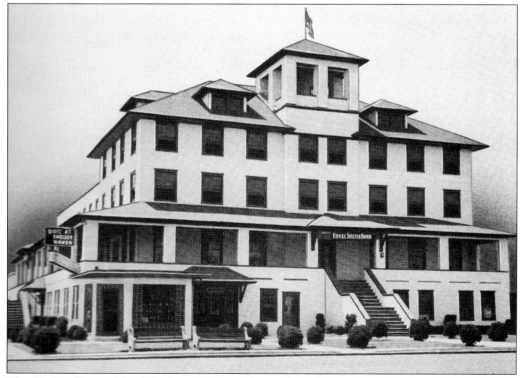

The Shelter Haven Hotel, built in 1912, was located on the corner of Ninth Street and Third Avenue and overlooked the Shelter Haven Basin. It was a great example of American Foursquare architecture, which, by design, provided roomy interiors for structures built on small lots and thus was popular in many resorts. (SHM.)

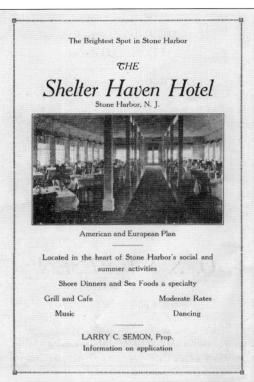

The Brightest Spot in Stone Harbor

THE

Shelter Haven Hotel
Stone Harbor, N. J.

American and European Plan

Located in the heart of Stone Harbor's social and
summer activities

Shore Dinners and Sea Foods a specialty

Grill and Cafe Moderate Rates

Music Dancing

LARRY C. SEMON, Prop.
Information on application

Built by brothers Jonathan Stryker and Frank Janson, the Shelter Haven Hotel was the largest building in town. In this advertisement from 1925, the Shelter Haven Hotel is noted as "the brightest spot in Stone Harbor," offering both "American and European Plan" packages. The American plan came with three meals a day, while the European option did not include meals. Along with its 60 guest rooms, the hotel's amenities included a dining room, café, barbershop, and poolroom. (SHM.)

Taken around 1936, this iconic image of the Stone Harbor Firemen's Band includes Mayor H. Irvin Gerhart and councilmen, along with police chief Michael Lennon. Entertainment at the Shelter Haven included concerts by the now famous Bill Haley and the Comets. Ownership of the hotel changed numerous times over the years, and in 1961, it was torn down to make way for a more modern structure. (SHM.)

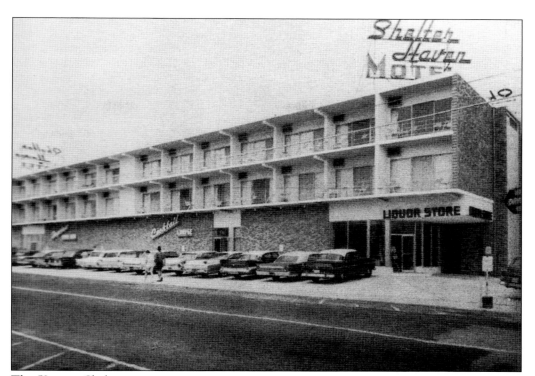

The 52-room Shelter Haven Motel offered a bar and liquor store as well as a heated swimming pool. Rooms were advertised as "informal" yet offered "every modern comfort." Off-season rates were lower than those during the summer, and a bay-view room looking out on Shelter Haven Basin would cost $2 more. Until demolished in 1999, the hotel went through many reincarnations, each with varying decor and entertainment configurations. From rock and roll to disco, bands and disc jockeys entertained crowds of visitors each and every evening in the year. (Right, SHM.)

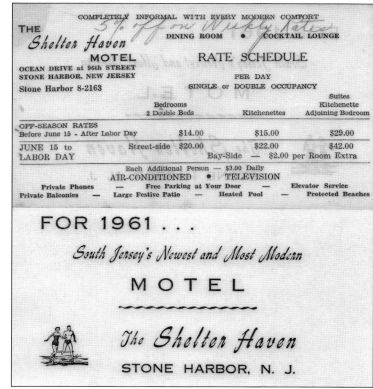

THE
Shelter Haven
MOTEL
OCEAN DRIVE at 96th STREET
STONE HARBOR, NEW JERSEY
Stone Harbor 8-2163

COMPLETELY INFORMAL WITH EVERY MODERN COMFORT
DINING ROOM • COCKTAIL LOUNGE

RATE SCHEDULE

PER DAY
SINGLE or DOUBLE OCCUPANCY

	Bedrooms 2 Double Beds	Kitchenettes	Suites Kitchenette Adjoining Bedroom
OFF-SEASON RATES Before June 15 - After Labor Day	$14.00	$15.00	$29.00
JUNE 15 to LABOR DAY Street-side	$20.00	$22.00	$42.00
	Bay-Side — $2.00 per Room Extra		

Each Additional Person — $3.00 Daily
AIR-CONDITIONED • TELEVISION
Private Phones — Free Parking at Your Door — Elevator Service
Private Balconies — Large Festive Patio — Heated Pool — Protected Beaches

FOR 1961 . . .

South Jersey's Newest and Most Modern

MOTEL

The Shelter Haven

STONE HARBOR, N. J.

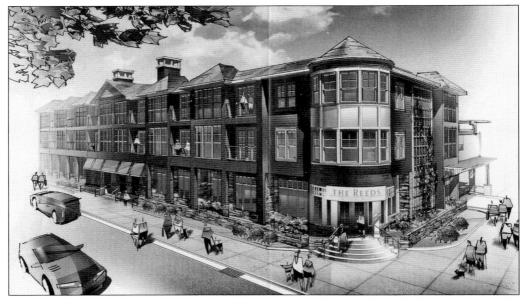

The Shelter Haven property sat vacant until new owners John Sprandio and Ed Breen opened the Reeds at Shelter Haven in 2013. A luxury facility with 37 rooms, it houses a restaurant, bar, and banquet rooms catering to large parties and weddings. A lovely bayside dining area maximizes the water views of Shelter Haven Basin.

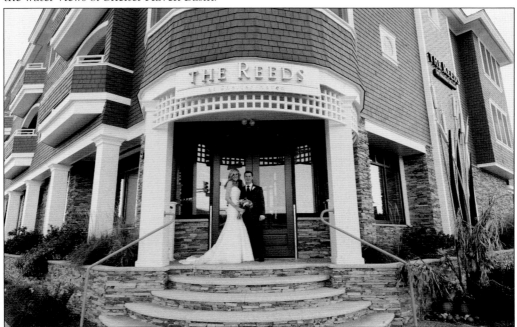

In 2013, Laura Henry and Blake Newman said their "I dos" on the upper deck of the newly opened Reeds at Shelter Haven. Having spent all her summers at the home of her grandmother in Stone Harbor, Laura wanted to be married within sight of the bay where she learned to swim. After the rooftop ceremony, the couple and their guests dined and danced as the sun set over Shelter Haven Basin. (Photograph by Hanne Photography, courtesy of LN.)

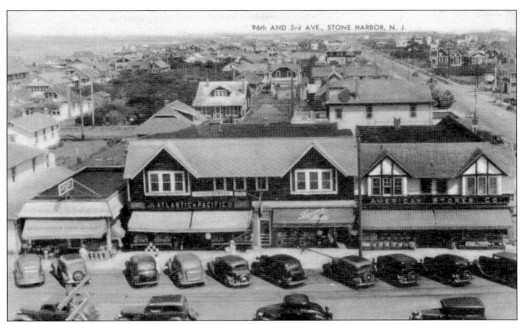

96th AND 3rd AVE., STONE HARBOR, N. J.

By the 1930s, the north side of the 300 block of Ninety-Sixth Street had become a booming commercial center. The A&P store, Stone Harbor Fish Market, and Leon's Market all provided residents and visitors alike with fresh produce and meats. These buildings still stand today, housing Uncle Bill's Pancake House and Green Cuisine. Leon's Market was one of the first grocers in Stone Harbor. In the 1927 county guide, Leon's is advertised as the "Only Store on Seven Mile Beach with Complete Electric Refrigeration." (Right, CP.)

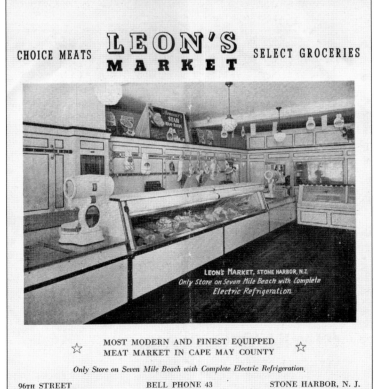

CHOICE MEATS **LEON'S MARKET** SELECT GROCERIES

LEON'S MARKET, STONE HARBOR, N.J.
Only Store on Seven Mile Beach with Complete Electric Refrigeration

☆ MOST MODERN AND FINEST EQUIPPED MEAT MARKET IN CAPE MAY COUNTY ☆

Only Store on Seven Mile Beach with Complete Electric Refrigeration.

96TH STREET BELL PHONE 43 STONE HARBOR, N. J.

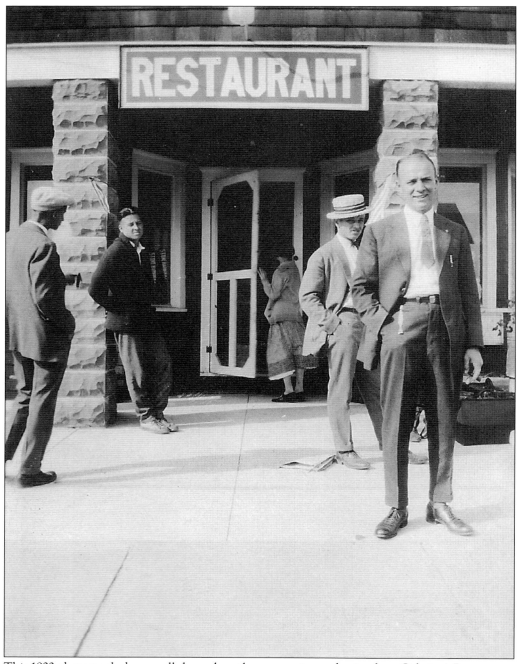

This 1922 photograph shows well-dressed gentlemen coming and going from Gehring's Restaurant. Note the man in the rear right sporting a boater. Jackets and ties were a must, even for an afternoon lunch or dinner.

Ninety-Sixth Street was home to two movie theaters. The Parkway Theatre opened in 1922 with a single screen and 460 freestanding chairs. This advertising brochure from 1927 announces that John S. Thompson of the Stanley Theatre in Camden would be playing the organ accompaniment for the rest of the season. It was only 30¢ a show—but no talkies yet.

On the south side of Ninety-Sixth Street stands the Harbor Theatre, built in 1949 and still in operation today. Author Donna Van Horn recalls her first summer job behind the candy counter at this theater in 1968. *With Six You Get Eggroll* was the summer's big hit. The single-screen theater had plush seating and an usher who would show patrons to their seats. The distinctive Art Deco tower and marquee are still local landmarks.

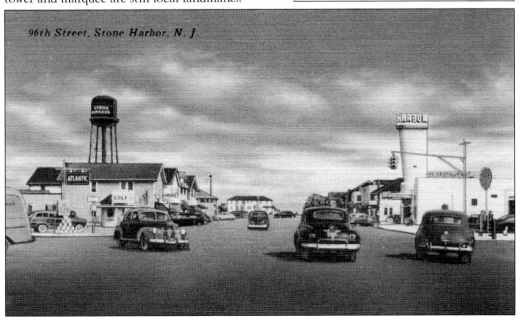

96th Street, Stone Harbor, N. J.

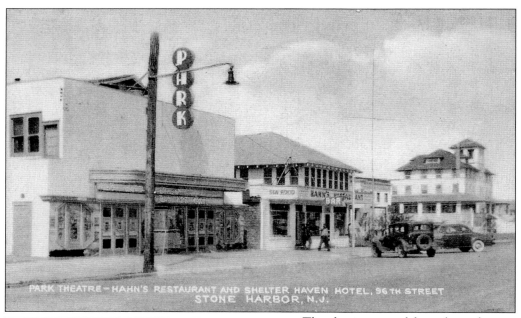

The above postcard from the early 1940s features the Park Theatre on the south side of Ninety-Sixth Street. The Park was demolished in 1988, but the Harbor lives on as a multiplex. In 1964, Tony Curtis was the headliner at the Harbor in *The Outsider*, with two nightly showings. On rainy days, a matinee feature was and is still added, and lines of families form early, seeking entertainment in lieu of the beach.

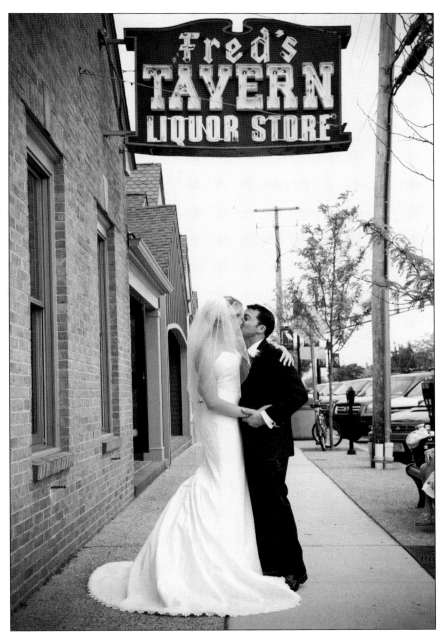

Fred's Tavern has occupied three different Ninety-Sixth Street addresses over the years. Its current location was originally called Mom Blum's Tent, until Fred Menzel and his sister Tillie purchased the property. Fred's is Stone Harbor's equivalent of Cheers, the place where everyone knows everyone else's name, and few patrons leave without a very recognizable Fred's T-shirt, which are often spotted all over the country. The sign over the front door has become such an iconic image of Stone Harbor that many newlyweds pose with it for wedding pictures, just as Sarah Van Horn and Mazen Yacoub did in 2011. Whether one is looking for a drink, a bite to eat, musical entertainment, or just a friendly bartender to have a chat, all can be found at Fred's. (Photograph by Andrew Graham Todes Photography.)

Hahn's Restaurant opened shortly after World War II and stood proudly in the center of Ninety-Sixth Street until 1984. The anchor sign towered above the street, hinting at the nautical decor to be found inside. At what was advertised as the longest bar in South Jersey, patrons entered on Ninety-Sixth Street, walked the length of the bar, and exited on Ninety-Seventh Street. It was originally owned by Martin Hahn, and Steven "Buck" Petosa and his wife, Dolores, bought the business and continued to build the restaurant's reputation for outstanding seafood. This rare advertising postcard is a souvenir of the restaurant's earliest days.

In 1956, Alexander Hemphill built Stone Harbor's first motel, the Tides, on the beach at Ninety-Sixth Street. With just 40 rooms, wall-mounted air-conditioning units, and no telephones, the Tides was certainly basic by today's standards, but it was the considered quite modern in its day. The building was demolished in 1984 to make way for the Sanderling condominiums.

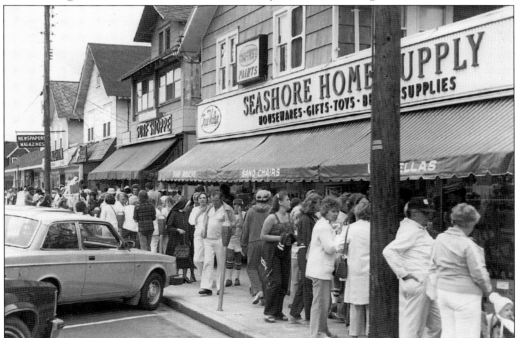

The annual sidewalk sale, sponsored by the Stone Harbor Chamber of Commerce, brings throngs of thrifty shoppers to Ninety-Sixth Street, all hoping to arrive early enough to score a really great deal. Merchants like the Seashore Home Supply happily clear out their summer inventories, making room for fall merchandise in preparation for the holiday shopping season.

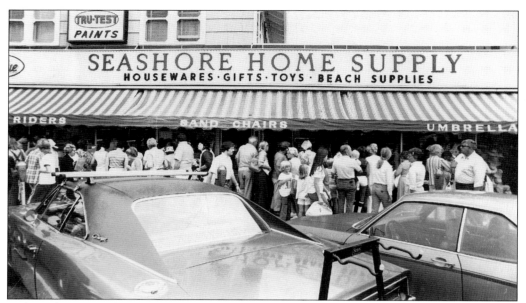

Spike Fisher originally founded Seashore Home Supply as an appliance store in 1946, but quickly realized that a hardware store would be more profitable. Most residents and visitors come to this store for housewares, paint, beach supplies, and deck furniture. The spring season is especially busy as people stock up on the necessary supplies to open their summer homes and spruce them up for the season.

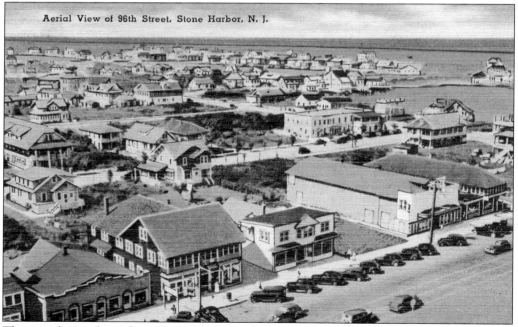

This aerial view from the early 1940s shows the south side of Ninety-Sixth Street. The brick building at far left once housed the post office. With a new brick facade at the time this postcard was printed, the building was home to three gift stores and souvenir shops. The original structure was eventually torn down, and this site is now the home of Hoy's 5 & 10.

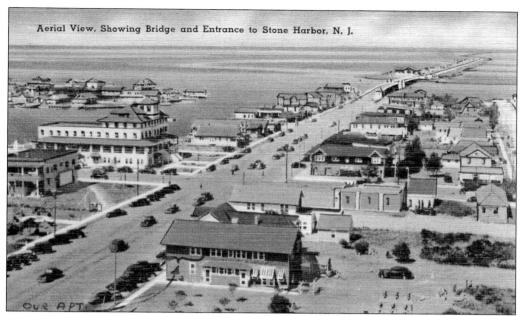

Aerial View, Showing Bridge and Entrance to Stone Harbor, N. J.

In this view looking farther west toward the Stone Harbor Parkway Bridge, the Shelter Haven Hotel dominates Ninety-Sixth Street. Notice in particular the undeveloped area at right over the bridge, heading toward the mainland where Stone Harbor Marina and Stone Harbor Manor now stand. At left over the bridge was a lumberyard, now the location of bayfront condominiums.

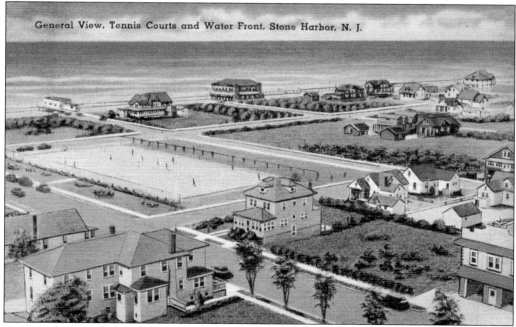

General View, Tennis Courts and Water Front, Stone Harbor, N. J.

On any given morning, the sound emanating from the south side of the 100 block of Ninety-Sixth Street is often the thwack of tennis balls, as seen in this postcard. For a small seasonal fee, avid tennis players can have unlimited access to five public courts, in addition to shuffleboard and basketball courts.

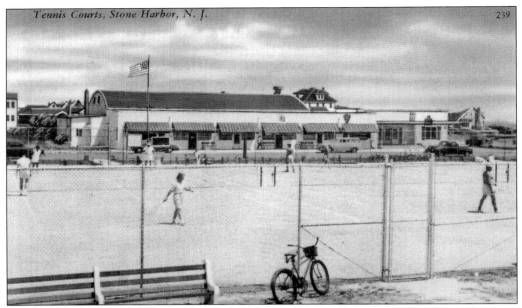

Across Ninety-Sixth Street from the tennis courts stood the Harbor Lanes Bowling Alley, built in 1948. Bowling was a great rainy-day activity until the lanes closed in 1973. Rain or shine, the bowling alley provided a place for teenagers to gather for the arcade games, pool tables, and a jukebox. The luncheonette was often filled with children sent from the beach to get a snack.

WATER WORKS, STONE HARBOR, N. J.

PHOTO BY ATLANTIC STUDIOS. CAPE MAY. N. J. 137994

This iconic building was Stone Harbor's second water pumping station and remains the oldest public building in the borough. Built in 1924, it housed the equipment necessary to pump water from the 856.5-foot well that reached water source from a source in the Pocono Mountains. The chain fence was replaced with a whitewashed cement wall, which has long been a designated place for families and friends to meet while shopping on Ninety-Sixth Street.

Ninety-Sixth Street has hosted hundreds of parades and festivals over the years. Bands, fire trucks, Scout troops, and floats draw thousands of spectators for each event. Below, the Stone Harbor Beach Patrol participates in an annual Memorial Day parade. Each year, the lifesaving boat is rowed out just beyond the waves and a wreath is placed in the ocean in remembrance of fallen soldiers.

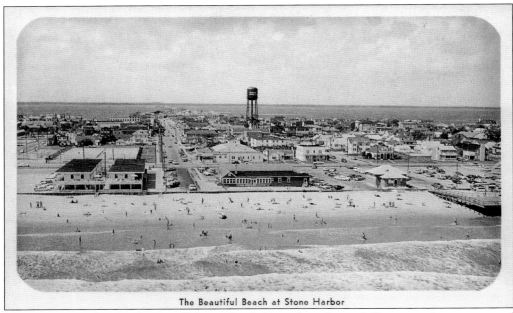

The Beautiful Beach at Stone Harbor

Over the years, the aerial view of Ninety-Sixth Street has changed. Businesses have come and gone, as have iconic buildings. The landmark water tower even sported the artwork of Peter Max in 2005. What has not changed, however, is the fact that the four blocks of Ninety-Sixth Street that span the distance from the Great Channel to the Atlantic Ocean are the heart and soul of Stone Harbor. Shoppers can find anything from suntan lotion and beach chairs to evening wear and fine jewelry, all available to ensure that no vacation is spent wanting for anything or ended leaving town without the perfect souvenir. No trip to Stone Harbor is complete without a stroll on this quintessential main street.

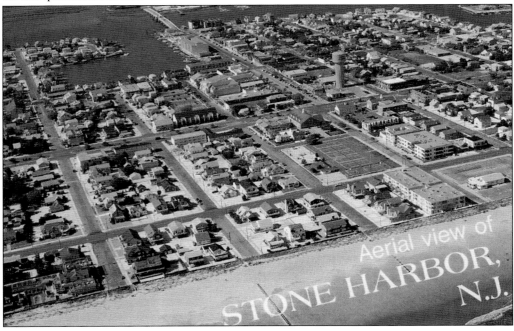

Aerial view of STONE HARBOR, N.J.

Six

A Reason to Celebrate

Most families have closely held traditions that dictate how they spend their holidays, celebrate special occasions, and honor the history of their own culture and background. When a new organization is founded, the first thing that members do is select a motto, or mascot, or flag by which they can identify, while also instituting a set of rules by which they will operate. This is all part of establishing tradition. How people celebrate holidays, for example, helps define them as a society. These customs give meaning to events and help anchor people to a specific time and place.

For many, Stone Harbor is tradition. The community itself is deeply proud of its history and cherishes the comfort that comes with celebrations rooted in a sense of "That is how we have always done it!" Whether it was the opening of the bridge connecting the island to the mainland, the dedication of a new church, or the opening of the Atlantic beaches for the summer season, there has long been reason to celebrate in Stone Harbor.

That is not to say that there has not been room for the creation of new traditions and celebrations over the years. Newer events, such as the Stone Harbor Shiver and the triathlon, have been added and are well on their way to "tradition" status. Time is marked by celebrations. They provide something to look forward to. Although Stone Harbor is predominantly a seasonal resort, year-round community events help mark the time between Memorial Day and Labor Day and celebrate the beauty of the island all year long. The crowds that descend upon Stone Harbor for Thanksgiving, New Year's Eve, and Easter rival those of the summer months and reinforce that any season is the best season for the shore.

Nothing signals the start of the summer season like Memorial Day Weekend and the traditional opening of the beach and ocean. Communities up and down the New Jersey coast pay homage to King Neptune while honoring the people who died in service to their country. Memorial Day was not declared a national holiday until 1971, but Stone Harbor celebrated Gala Day by throwing flowers into the ocean in memory of fallen veterans. It was a special honor to be selected to be part of this very solemn celebration. At left, Gladys Letzkus (second from left) and Lucile Springer Clark (fourth from left) join Mayor George L. Markland in official ceremonies on the beach in 1926. Below, George Salrenson (foreground) and members of the police department prepare to launch a small boat filled with flowers into the Atlantic Ocean. (Both, SHM.)

On July 3, 1911, Gov. Woodrow Wilson joined in the Gala Week festivities, cutting the ribbon to open the new Stone Harbor Parkway and Bridge. These never before published photographs were taken by W.N. Jennings to commemorate this historic occasion. From July 1 to 5, Stone Harbor was the epicenter of numerous events planned to attract further investors to the community and to celebrate the opening of the Ocean Parkway. Automobile races, a formal ball at the yacht club, a beach party and barbecue, a water carnival, and fireworks were on the schedule. It was the opening of this roadway and bridge connecting Stone Harbor directly to Cape May Court House that ensured the success of the community's development. (Both, RD.)

The festive band above was photographed in 1925 as members readied for the July Fourth parade. Just as today, the parade hosted bands, floats, and groups of marching children. The large group of children below is participating in an annual race as part of Independence Day festivities in 1994. Participants of all ages lined up by the hundreds for the chance to prove their speed and take home a prized trophy. Although the competition is all in fun, the determination on some of these faces could lead one to believe this was a qualifying event for the Olympics. After the races, the action moved to the beach for a sand-sculpting contest. The day ended with fireworks over the beach. Although, for a few years in the 1960s, the aerial rockets were replaced with ground displays and a donkey baseball game on the ball field at Eighty-Third Street. (Above, SHM.)

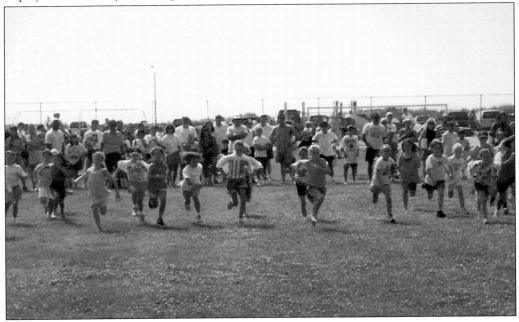

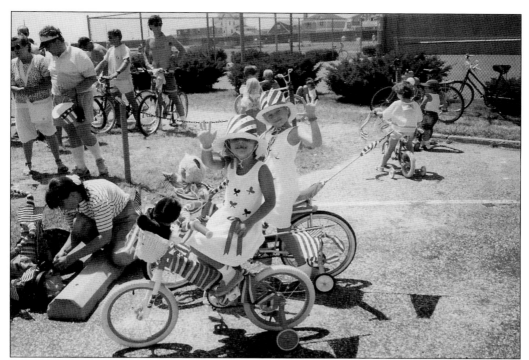

July Fourth always includes a decorated bike contest. In 1990, Ashley (left) and Sarah Van Horn dressed in red, white, and blue, right down to their hats, to match their bikes. In keeping with the patriotic theme, their teddy bears came along for the ride.

Vicki Mills Rosell

Micky Mills Pearson

Baby parades were once all the rage along the boardwalks of the Jersey Shore. In 1890, the first baby parade in the country was hosted in Asbury Park, New Jersey. Stone Harbor's first baby parade was held in 1922. In the early days, the parades filled the boardwalk, with children in fancy dress and elaborate costumes. One of the first local parades included sisters Vicky Mills Rosell and Micky Mills Pearson in full fancy dress costumes. (SHM.)

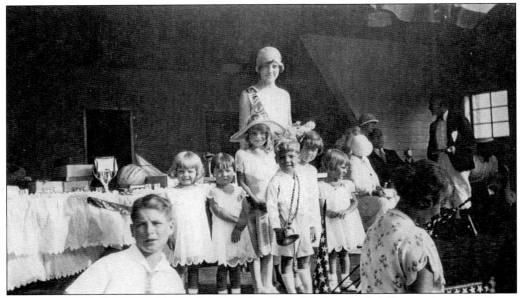

This photograph from 1929 shows the first Miss Stone Harbor, Mabel Sheer, who reigned over the baby parade. Beginning in 1955, local resident Vicky Wear and councilman Jack Fitzpatrick chaired a pageant in which residents cast ballots to select the annual Little Miss Stone Harbor. Girls ages six through ten competed for this coveted title. The little miss and her court then went on to sit in an honored place on a float in the baby parade. (SHM.)

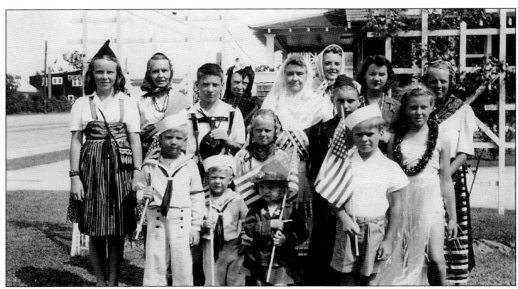

In 1943, Sara Bunting chaired the annual baby parade. She is pictured here with some of the entrants, dressed in a variety of costumes from around the world. Notice the number of military-themed costumes, appropriate considering that World War II was raging in Europe and the Pacific. (SHM.)

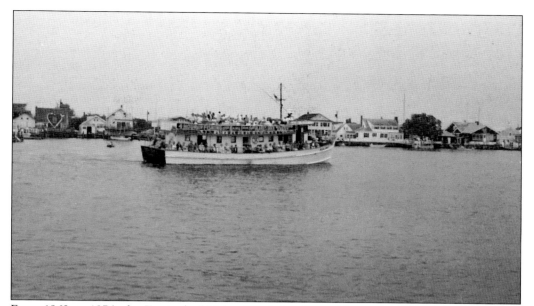

From 1962 to 1976, the Festival of Lights filled the Great Channel with decorated boats of every size and shape for a parade in and out of all the basins. Crowds of people on elaborately decorated docks greeted the boats all along the parade route. In celebration of Stone Harbor's 100th anniversary, the Festival of Lights was reintroduced in 2014 and is expected to once again become an annual event.

The Women's Civic Club was organized in 1913 to promote the enhancement of Stone Harbor through charitable and civic activities. The group's headquarters at the beach on Ninety-Sixth Street has been home to thousands of teen dances, art classes, antique shows, and private parties and weddings. The Stone Harbor Seniors, founded in 1970, has held many a gathering there, including this one featuring a member's band, with lead singer Carey Boss.

In this photograph from 1910, a cast of costumed players prepares for a performance to raise funds to build a Catholic church at Ninety-Ninth Street and Third Avenue on a plot of land donated by the Risleys. Various social affairs and entertainments were undertaken to further support this effort. Charlotte and Mary Kienzle appear third and second from right. (RD.)

On Sunday, July 3, 1910, the first Catholic Mass offered on Seven Mile Beach was held in a pavilion owned by George J. Rummel. This photograph was taken on July 2, 1911, when the community celebrated the first Mass in the newly constructed church. The Right Reverend Msgr. John Fox of the Diocese of Trenton conducted the service. (RD.)

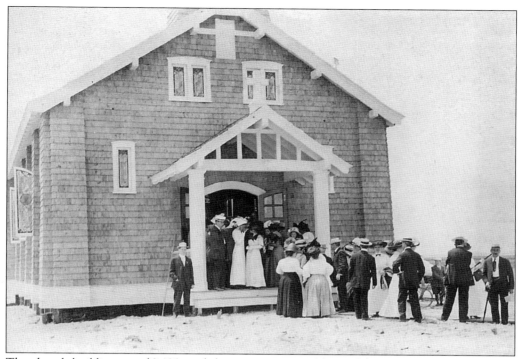

The church building cost $3,400, and the pews were an additional $365. Catholic services were provided from June through September, with a break during the winter months. From 1914 until 1936, St. Paul's Parish was under the supervision of Msgr. James A. Moroney, who traveled to Stone Harbor from Wildwood for each Sunday's Mass. This photograph depicts the joy felt in the community with the opening of the church. (RD.)

Visitors to Stone Harbor during the week of Thanksgiving will attest to the fact that the crowds in town are almost as large as those on July Fourth. On Saturday night of Thanksgiving weekend, the entire downtown shopping district turns into a winter wonderland, with festive lights and holiday decorations, as people line Ninety-Sixth Street to watch the annual Christmas parade and the arrival of Mr. and Mrs. Santa Claus.

New Year's Eve sees the return of many seasonal residents and tourists alike to celebrate the holiday with a winter getaway to Stone Harbor. There is nothing as peaceful as a walk on the beach in the wintertime, especially if it is covered in snow. Local restaurants offer prix fixe specials, and the trolleys run the length of town, so revelers do not have to drive. On December 31, 1999, these summer friends gathered to ring in the new millennium. From left to right are Sarah Van Horn, Kimberly Shacochis, and unidentified.

For many summer residents of Stone Harbor, Labor Day means packing up and heading back to homes in other states. With the end of the long summer days and the opening of school right around the corner, it is time to say good-bye to the beach, the bay, and summer friends. Pictured here in the 1960s, the George Mehl family is packed and ready to return to Massachusetts, with Comet sailboat and all. (LCK.)

126

BIBLIOGRAPHY

Adams, Charles J. III, and David J. Seibold. *Shipwrecks and Legends 'Round Cape May.* Wyomissing Hills, PA: David J. Seibold, 1987.

Boyer, George F., and J. Pearson Cunningham. *Cape May County Story.* Avalon, NJ: Avalon Publishing Company, 1975.

Buchholz, Margaret Thomas. *New Jersey Shipwrecks: 350 Years in the Graveyard of the Atlantic.* West Creek, NJ: Down the Shore Publishing, 2004.

———, ed. *Shore Chronicle: Diaries and Travelers' Tales From the Jersey Shore: 1764–1955.* Harvey Cedars, NJ: Down the Shore Publishing, 1999.

Cole, T. Mark, and Cheryl Glasgow. *Stone Harbor.* Images of America. Charleston, SC: Arcadia Publishing, 2001.

———. *Stone Harbor.* Postcard History Series. Charleston, SC: Arcadia Publishing, 2004.

Dorwart, Jeffery M. *Cape May County, New Jersey: The Making of an American Resort Community.* New Brunswick, NJ: Rutgers University Press, 1993.

Lencek, Lena, and Gideon Bosker. *The Beach: The History of Paradise on Earth.* New York: Viking Penguin, 1998.

Stevens, Lewis Townsend. *The History of Cape May County, New Jersey: From the Aboriginal Times to the Present Day.* Cape May City, NJ: Lewis Stevens Publisher, 1897.

Stone, Herbert L. *The ABC of Sailing.* New York: Dodd, Mead and Company, 1946.

Stopyra, Diane, ed. *Stone Harbor: One Hundred Years of the Seashore at its Best.* Cape May, NJ: Exit Zero Press, 2014.

Tomlin, Charles. *Cape May Spray.* Philadelphia: Bradley Brothers, 1913.

Turner, James Lincoln. *Seven Superstorms of the Northeast.* Harvey Cedars, NJ: Down the Shore Publishing, 2005.

Van Horn, Donna, and Karen Jennings. *Sea Isle City Revisited.* Images of America. Charleston, SC: Arcadia Publishing, 2014.

Way, Julius. *An Historical Tour of Cape May County, New Jersey.* Sea Isle City, NJ: Atlantic Printing and Publishing Company, 1930.

DISCOVER THOUSANDS OF LOCAL HISTORY BOOKS FEATURING MILLIONS OF VINTAGE IMAGES

Arcadia Publishing, the leading local history publisher in the United States, is committed to making history accessible and meaningful through publishing books that celebrate and preserve the heritage of America's people and places.

Find more books like this at
www.arcadiapublishing.com

Search for your hometown history, your old stomping grounds, and even your favorite sports team.